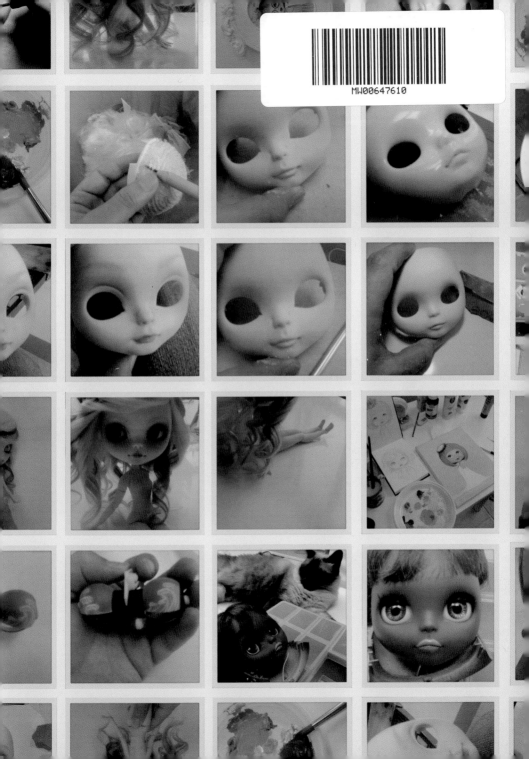

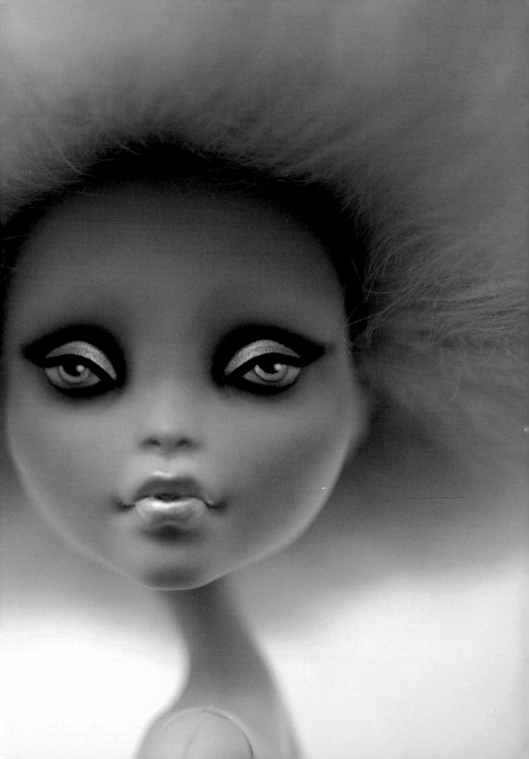

Super Cute Dolls
The art of Erregiro

Copyright ©2012 Instituto Monsa de Ediciones

Editor, concept and project director
Josep Maria Minguet

Co-Author
**Rafael Rodríguez Girona
(Erregiro)**

All photographs by
**Rafael Rodríguez Girona
(Erregiro)**

Art director, text, design and layout
Louis Bou @ Monsa Publications

©2012 Instituto Monsa de Ediciones
Gravina, 43
08930 Sant Adrià del Besòs
Barcelona-Spain
Tel. +34 93 381 00 50
Fax +34 93 381 00 93

monsa@monsa.com
www.monsa.com

**Visit our official online store!
www.monsashop.com**

ISBN 978-84-15223-49-8

D.L B-3339/2012

Printed in Spain by Cachiman Grafic, S.L.

pages 4 & 5: Cloud Girl by Erregiro

Super Cute Dolls

The art of Erregiro

selected by Louis Bou

monsa

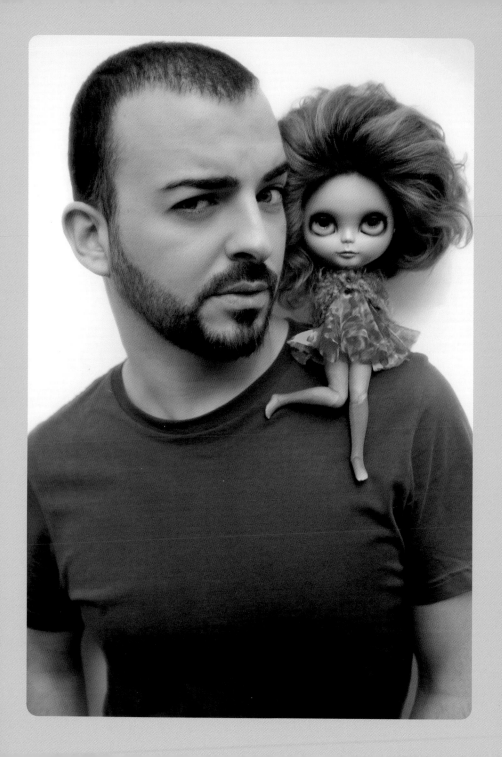

¿Who the hell is Erregiro?

Rafael Rodriguez Girona (Sevilla 1980) is Erregiro. He graduated by the University of Seville in fine arts, specialized in design and etching. Erregiro is a tireless dreamer, an art lover, from an early age he felt the need to share little pieces of his inner world with the rest of the people around him, first using pencil and paper, later with his paintings, etchings, photographs, and finally with his customization of the Blythe doll, using it as "raw material" to generate his lovely characters, recreating situations, scenes and sensations, and as a result of it all, Erregiro has become an admired and highly respected artist in the international custom dolls scene. After the design of the character and the customizing work–the plastic surgery–each of his "girls", as he likes to call them, are reflected in various photo shoots, set in different styles or nature of each of his "girls." Erregiro's work has been selected and awarded in various competitions, and also he has participated in countless exhibitions. His amazing dolls have been published in the book *Toyland*, from Monsa Publications, and in the Danish magazine *Paf Magazine*.

¿Quién demonios es Erregiro?

Rafael Rodríguez Girona (Sevilla 1980) es Erregiro. Se licenció en bellas artes en la Universidad de Sevilla en la especialidad de diseño y grabado. Erregiro es un soñador incansable, amante del arte, desde una temprana edad sintió la necesidad de compartir pequeños pedazos de su mundo interior con los demás, primero usando lápiz y papel y con el paso del tiempo vendrían la pintura, el grabado, la fotografía, y finalmente sus customizaciones de la muñeca Blythe, a la que usa como materia prima para engendrar personajes con los que recrea situaciones, escenas y sensaciones, y gracias a ello se ha convertido en todo un referente a nivel internacional en la escena de customización de muñecas. Tras el diseño del personaje y el trabajo de customización, la cirugía plástica, cada muñeca que crea, queda reflejada en diferentes sesiones fotográficas, ambientadas en los distintos estilos y caracteres de cada una de sus "chicas". Su obra ha sido seleccionada y premiada en distintos concursos y también ha participado en infinidad de exposiciones. Sus maravillosas muñecas han sido publicadas en el libro Toyland de la editorial Monsa y en la revista digital danesa Paf Magazine.

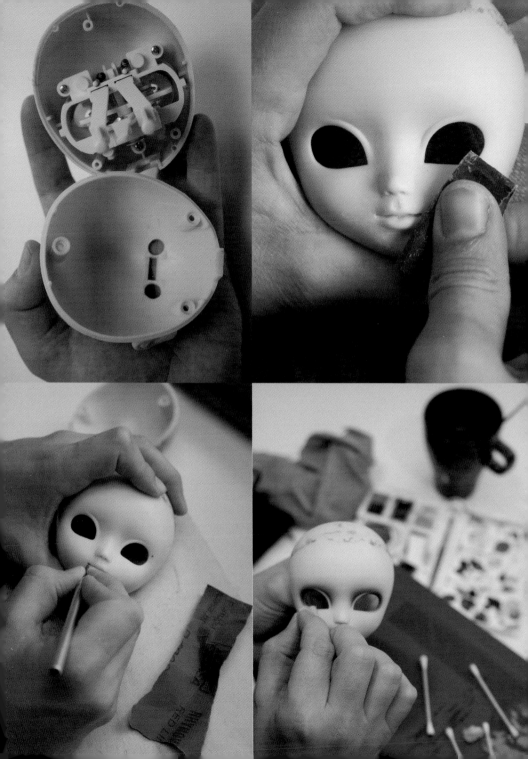

Blythe, Pullip, Monster High and Other Girls on the Heap...

"My girls," this is how I like to call them lovingly. My meeting with Blythe reopened the doors to let in my childhood, my child's imagination, so it could be said that I'm living one of the most creative periods of my life. Far from consider them just dolls, to me they have almost become my means of expression, the binding of all I wanted to do since I was a kid. Each time I create a new custom doll, I'm feeling like a designer, a sculptor, a painter, a makeup artist, a stylist, a photographer, and a storyteller. I've found the ideal medium that allows me to use traditional techniques and be original, and innovative at the same time. For me it's a complete artistic process that turns a doll, as it comes packaged from the factory, into a unique small piece of art, exclusive, and one-of-a- kind. Pullip, Monster High, and even Littlest Pet Shop, have been the last to arrive to my little studio to keep creating new characters, and I've been pleasantly surprised. Retired stock makeup, I've discovered a wonderful base to create other characters, more allegorical or oneiric. I think that any mold can be a source of inexhaustible inspiration. You just have to discover the beauty beneath the nakedness of its shape.

Blythe, Pullip, Monster High y otras *"chicas"* del montón...

"Mis chicas", así es como me gusta llamarlas cariñosamente. Mi encuentro con Blythe abrió de nuevo las puertas a mi infancia y dejó entrar mi imaginación de niño, desde entonces estoy viviendo una de las etapas más creativas de mi vida. Lejos de considerarlas tan sólo muñecas, para mí se han convertido prácticamente en mi medio de expresión y unión de todo lo que deseaba hacer desde pequeño. Cuando creo una custom puedo sentirme diseñador, escultor, pintor, maquillador, estilista, fotógrafo, narrador... He encontrado el soporte idóneo que me permite usar técnicas tradicionales y a la vez resultar originales e innovadoras. Para mí es un proceso artístico completo que convierte a una muñeca de fábrica en una pequeña pieza única, exclusiva e irrepetible. Pullip, Monster High e incluso Littlest Pet Shop, han sido las últimas en llegar a mi pequeño estudio para seguir creando nuevos personajes y me han sorprendido gratamente. Retirado el maquillaje de stock, he descubierto una base maravillosa para crear otro tipo de personajes, más alegóricos u oníricos. Creo que cualquier molde puede ser una fuente de inspiración inagotable, simplemente tienes que ver la belleza que se esconde en la desnudez de su forma.

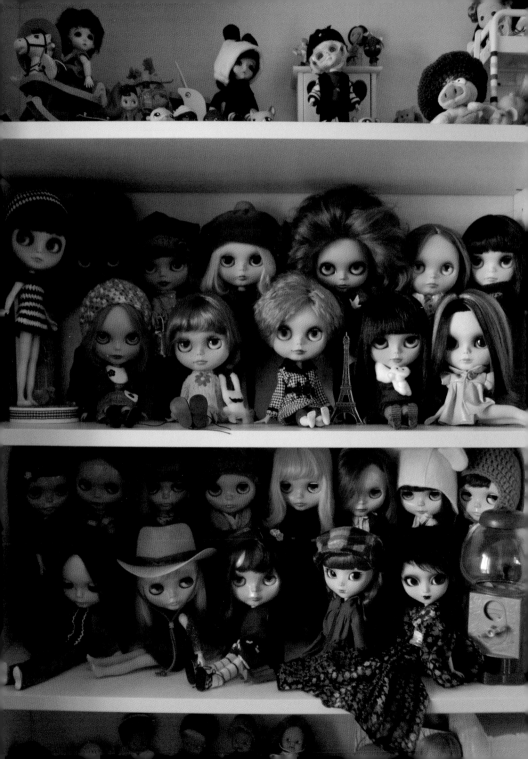

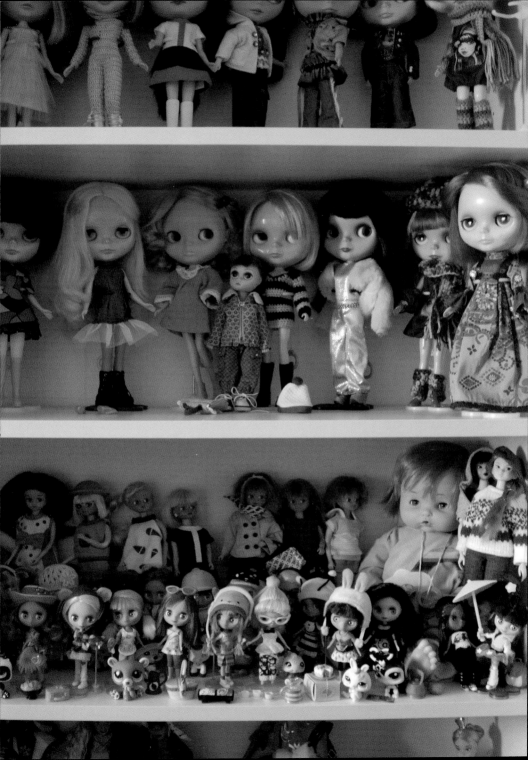

Home

14 & 15

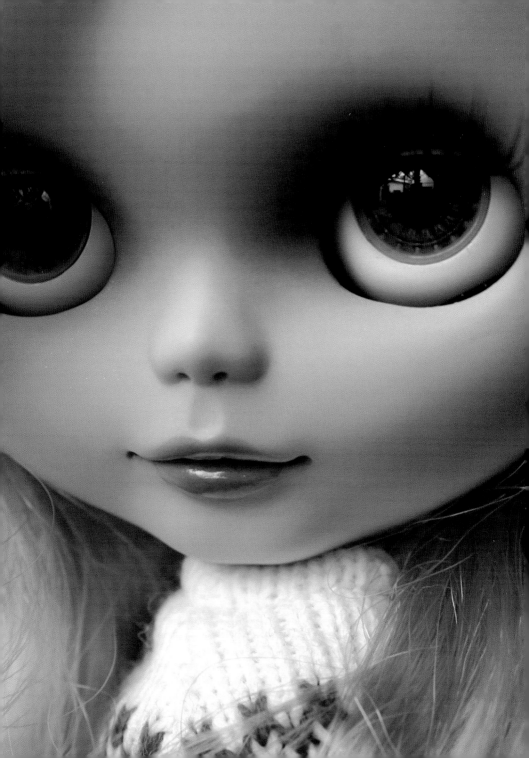

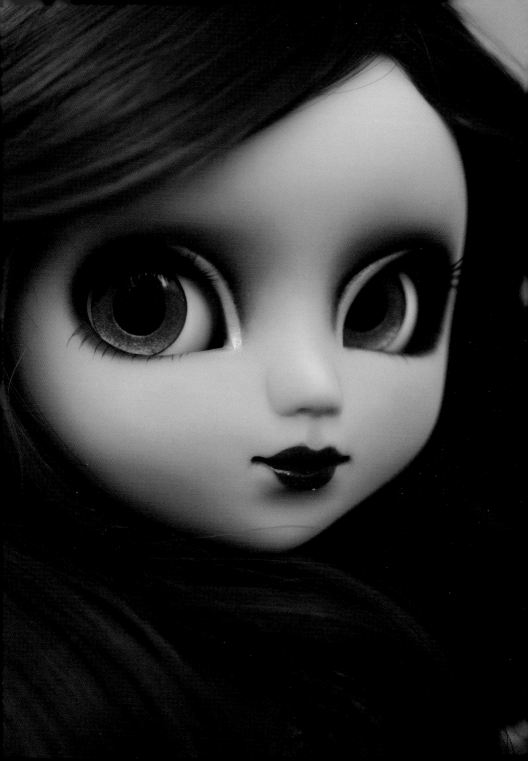

Hunted
Inspiration
19

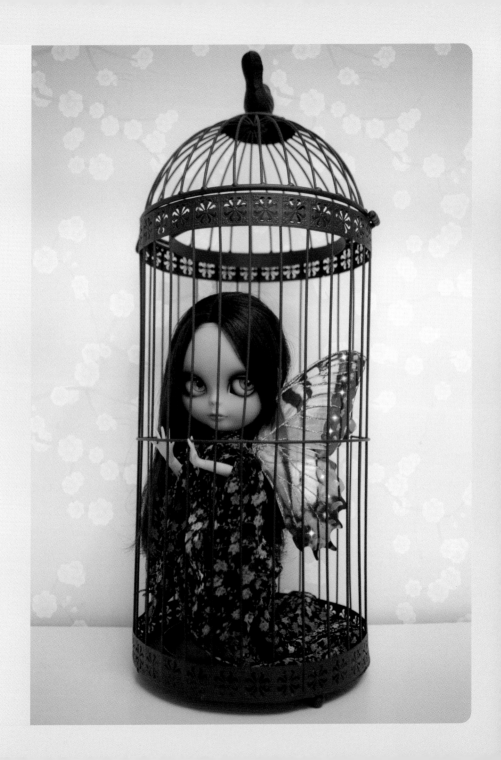

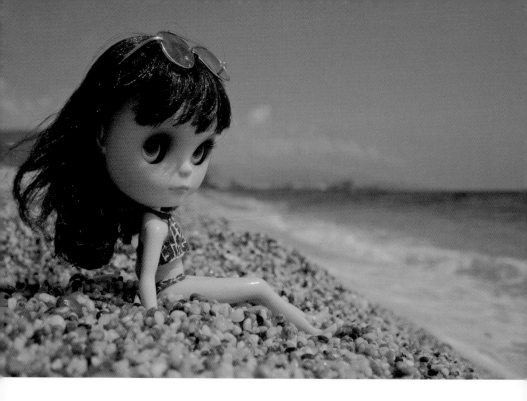

Think!
20

Florida Girls
21

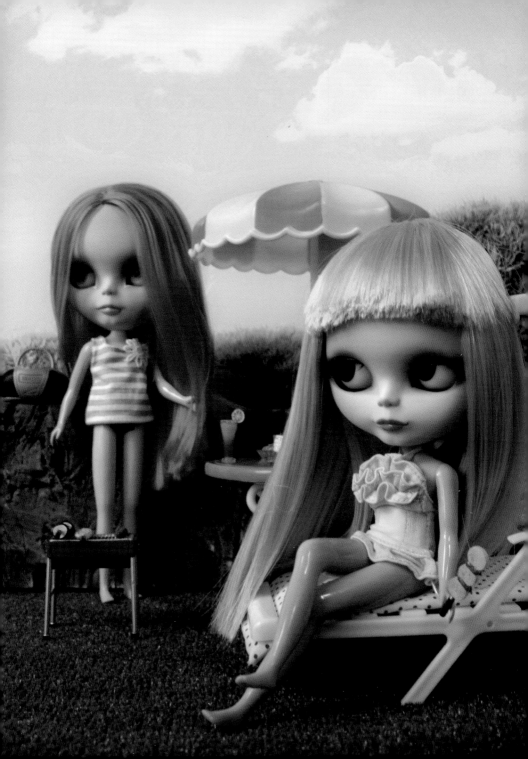

Alisha
22 & 23

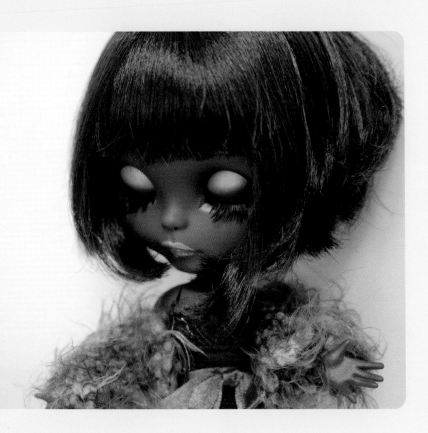

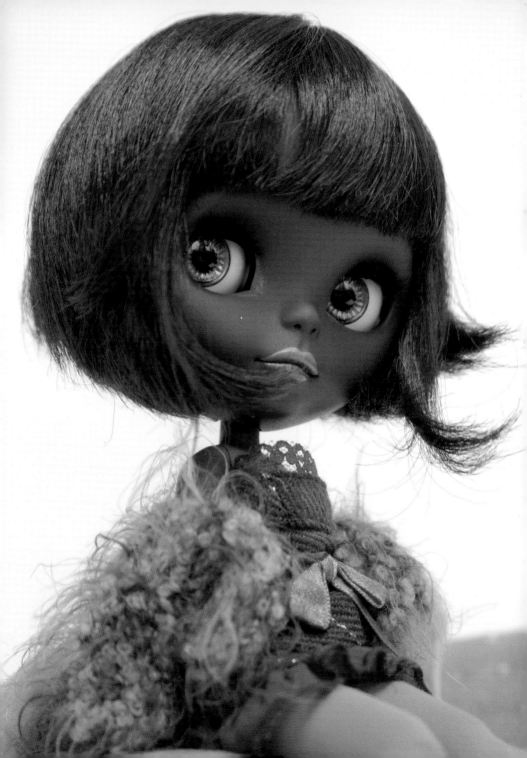

Would you?

24 & 25

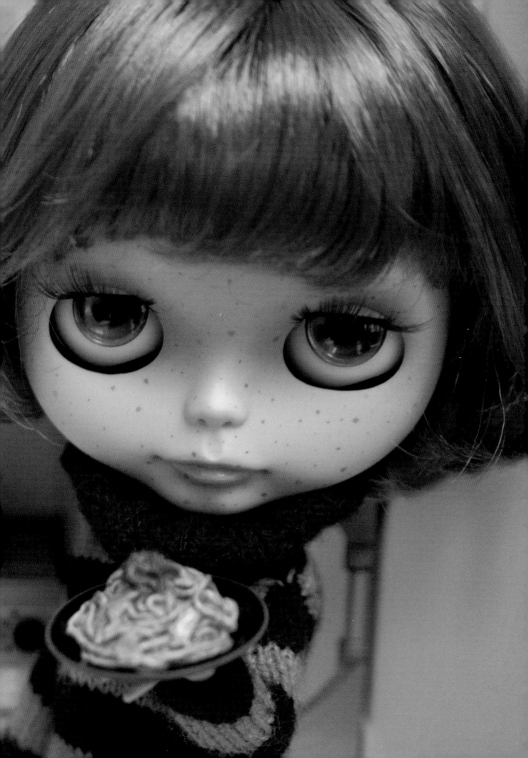

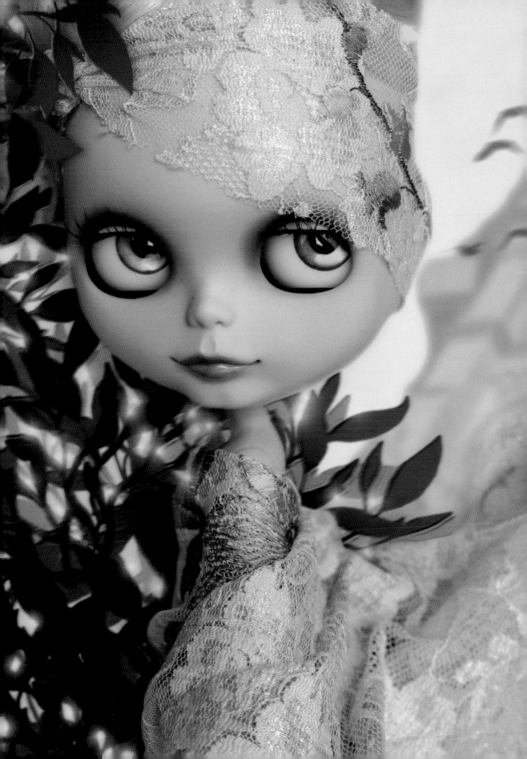

Notre Dame Pigeons

26 & 27

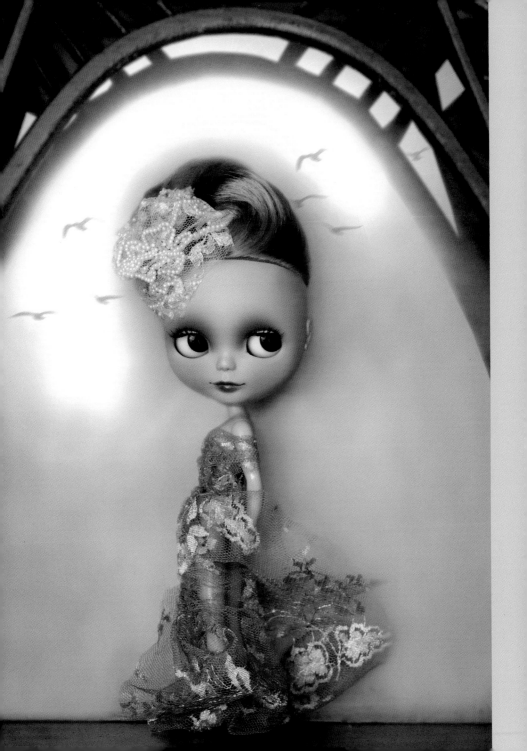

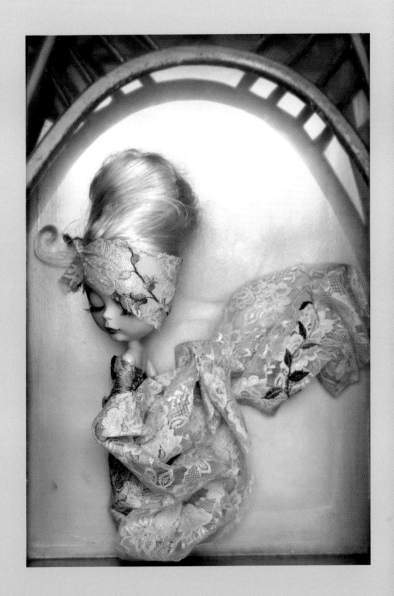

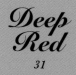

Deep
Red

31

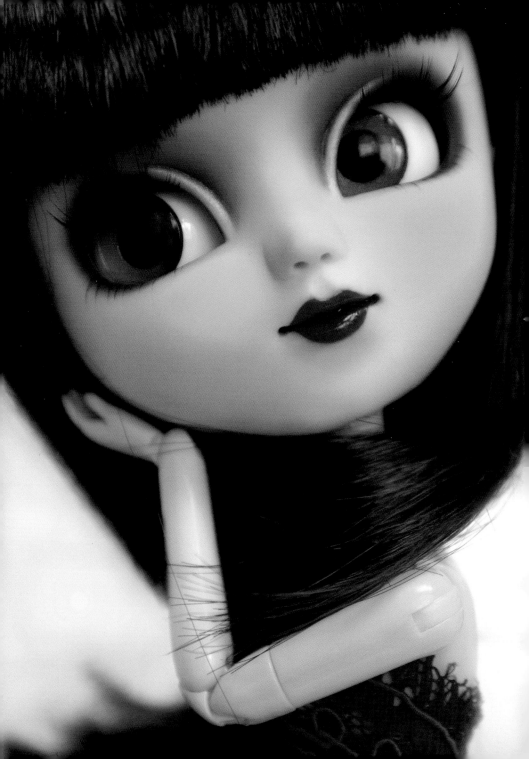

The
Hope Sailor

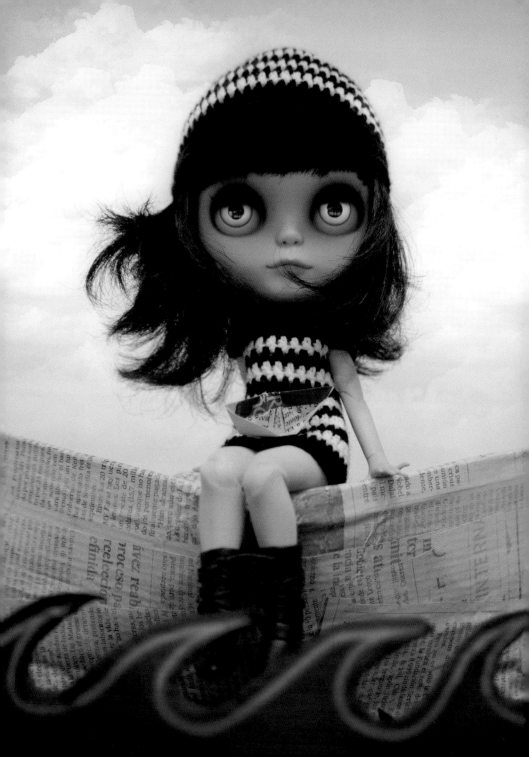

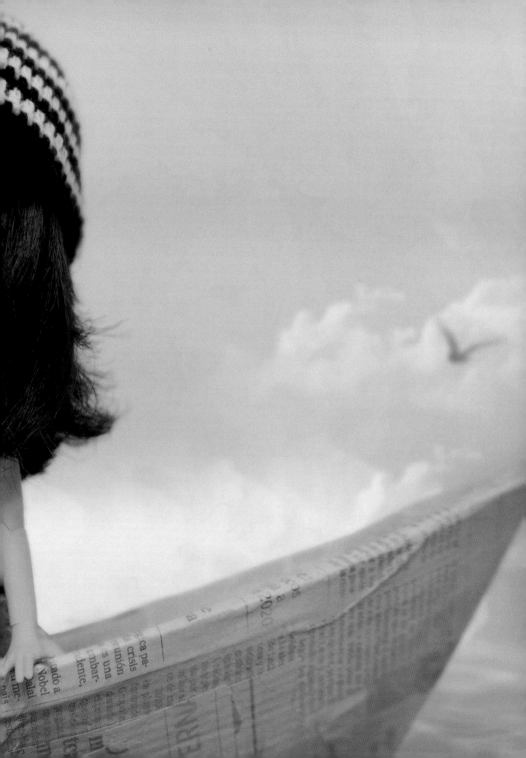

The Beginning

37

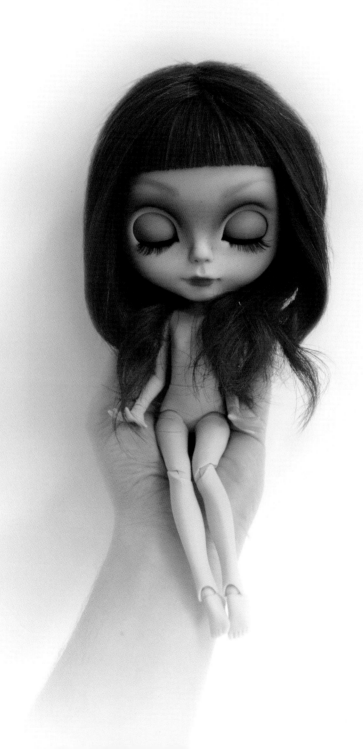

Cleopatra

38 > 41

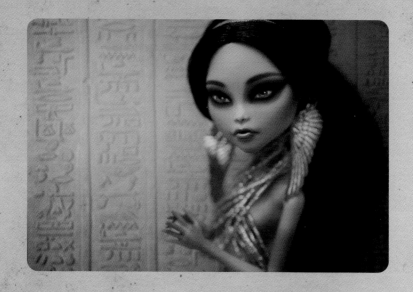

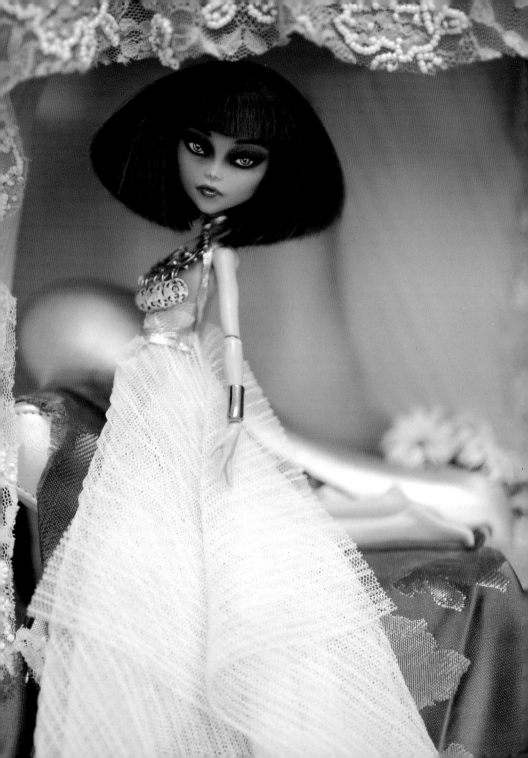

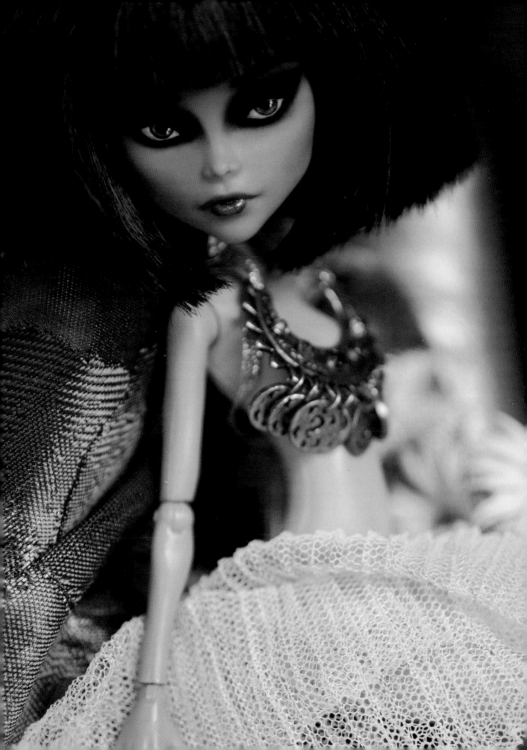

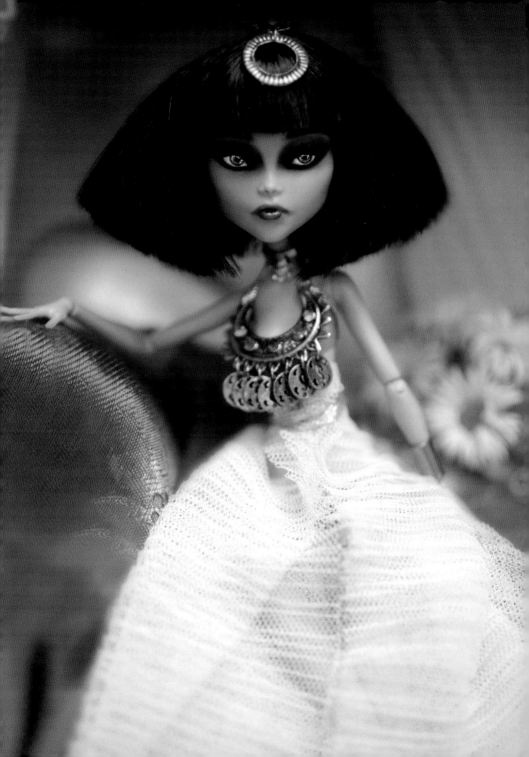

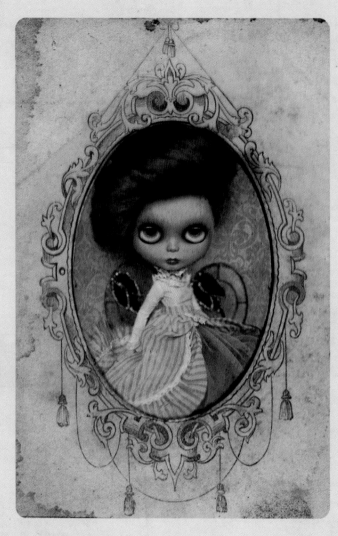

Memories
42 & 43

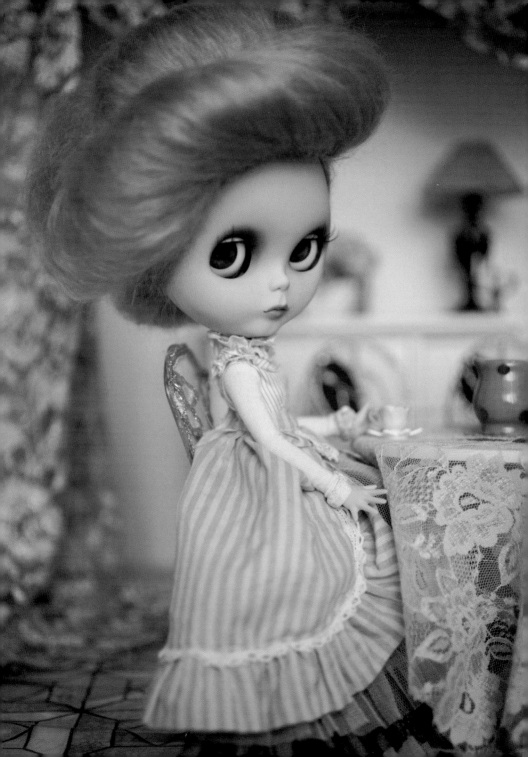

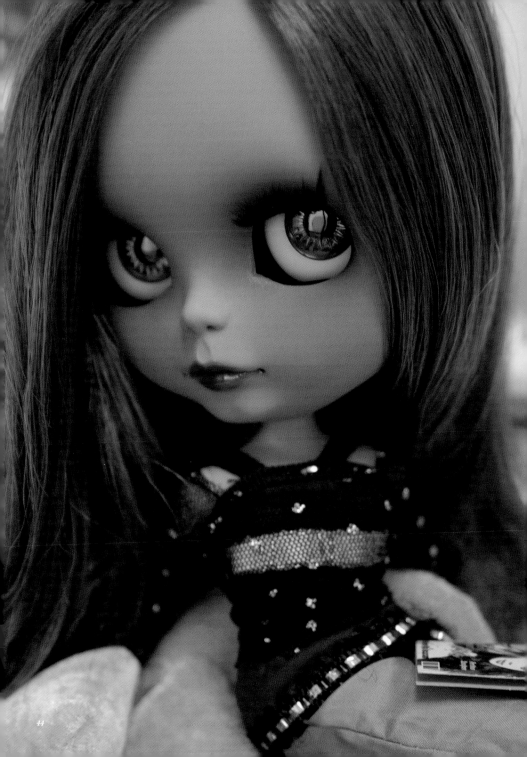

Magazine
Time
44 & 45

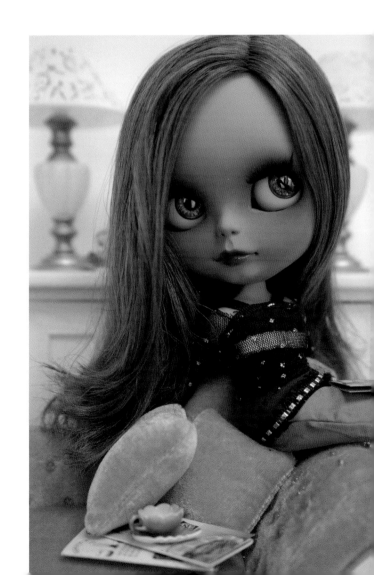

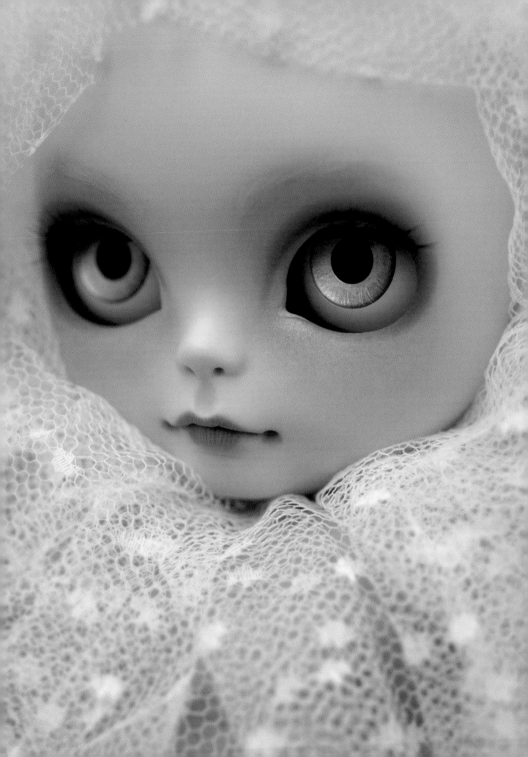

Happy
Halloween
48 & 49

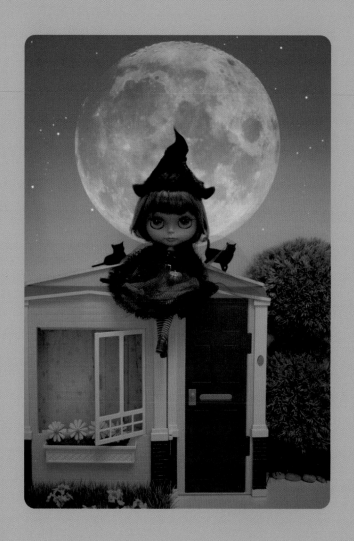

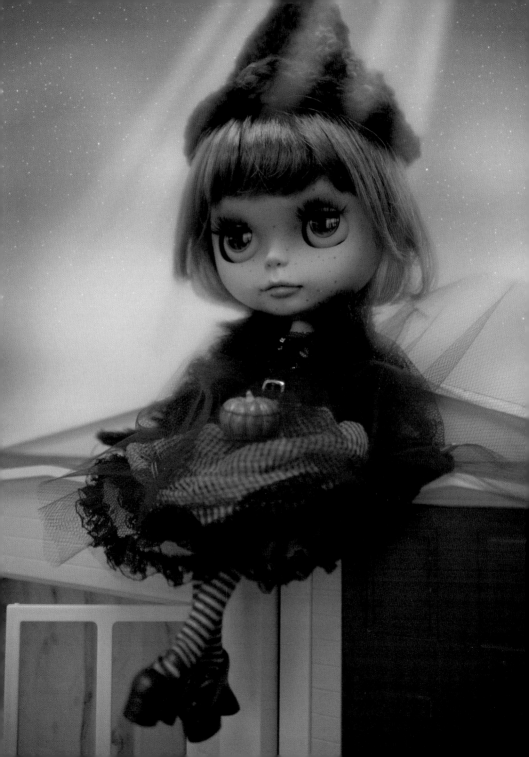

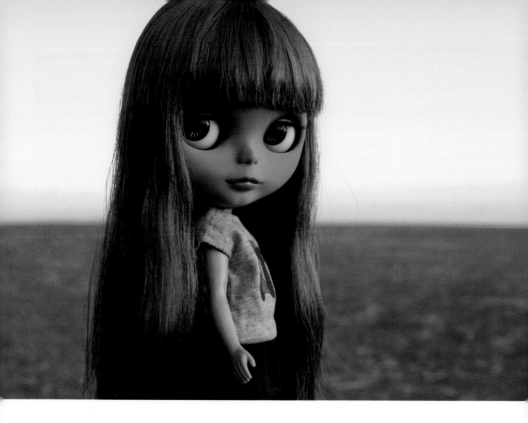

Sunsets

50 & 51

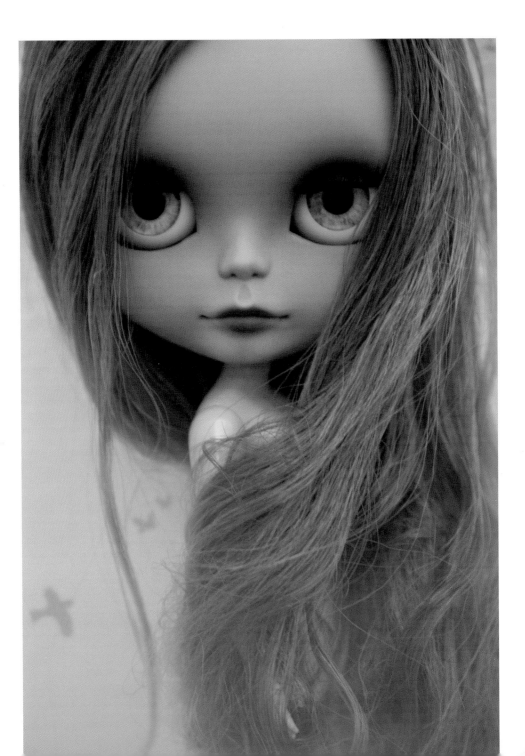

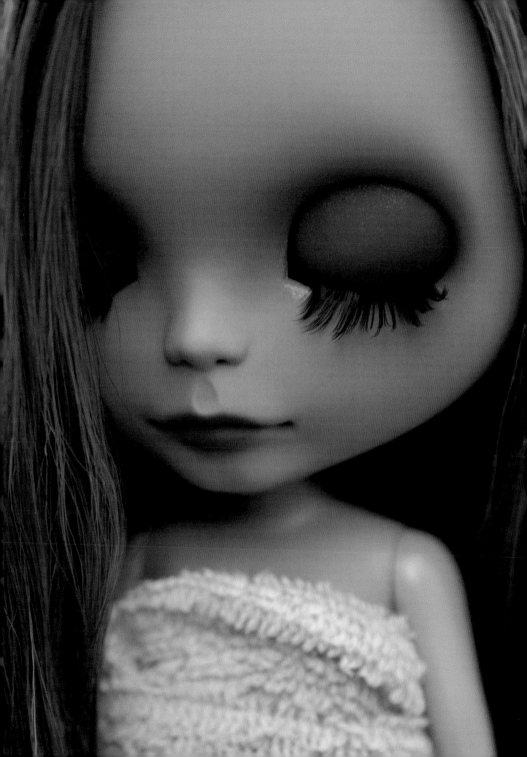

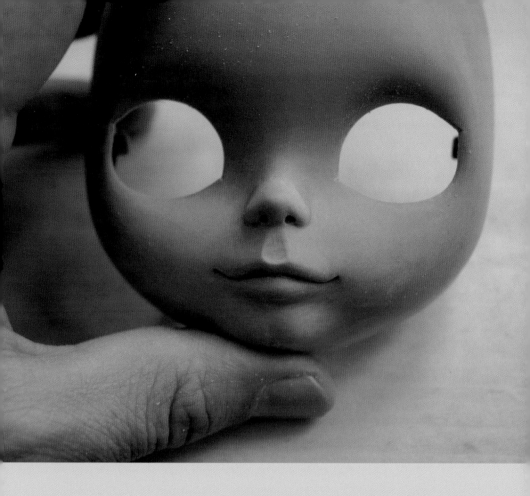

Spa Time

52 & 53

Vanora
The Little Wave
54 > 57

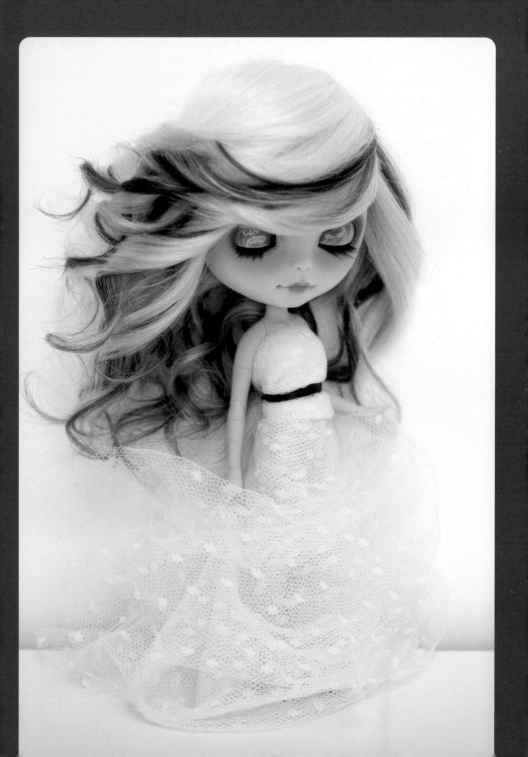

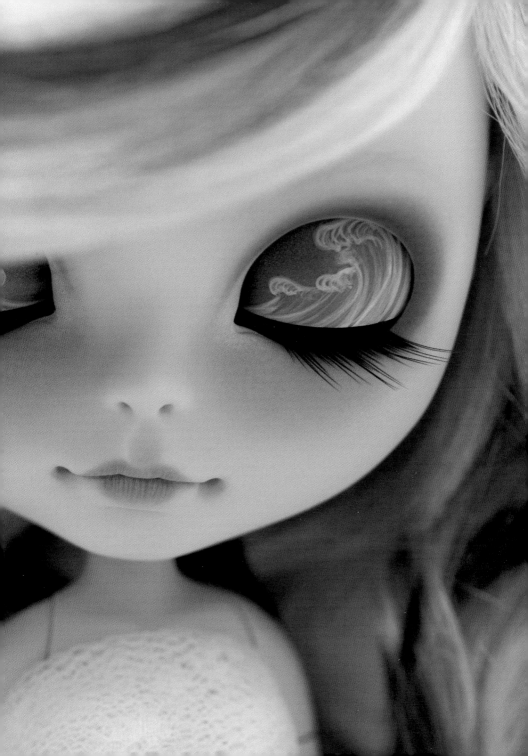

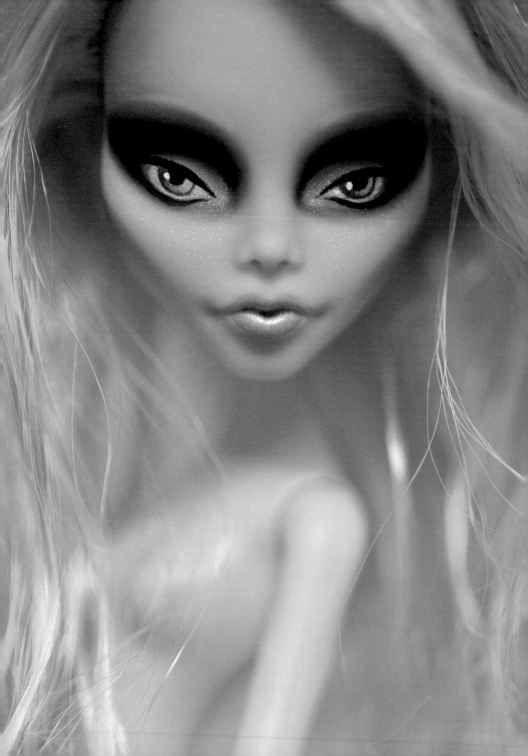

Engendrulia

Nenufar

61

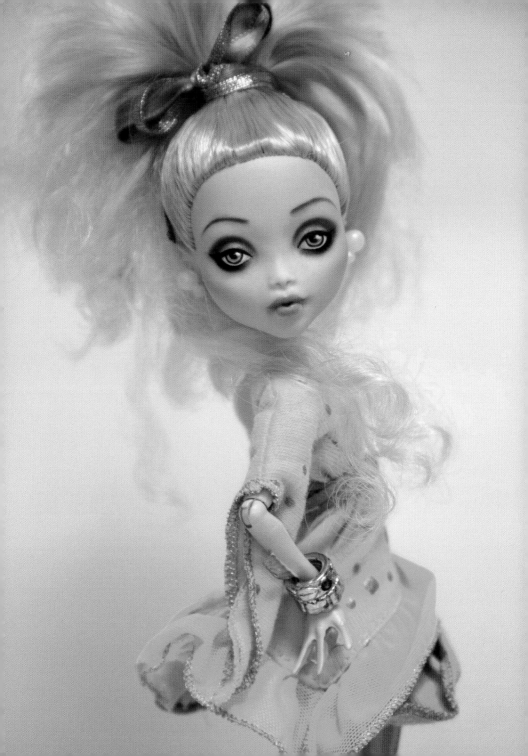

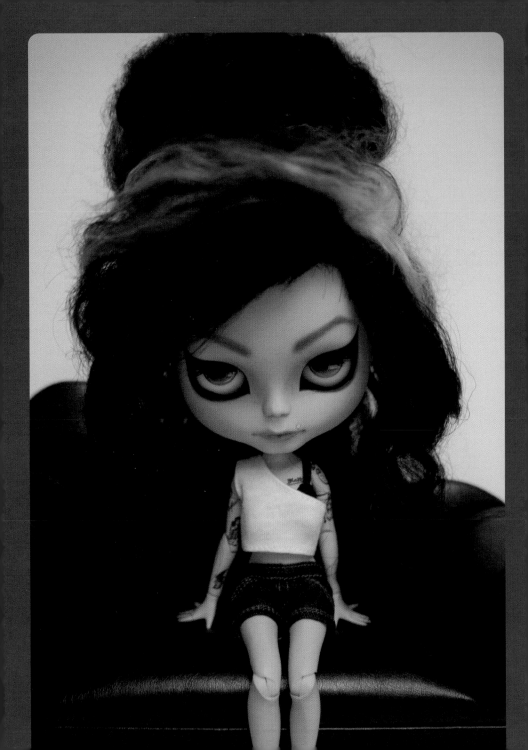

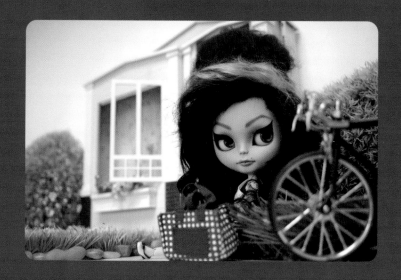

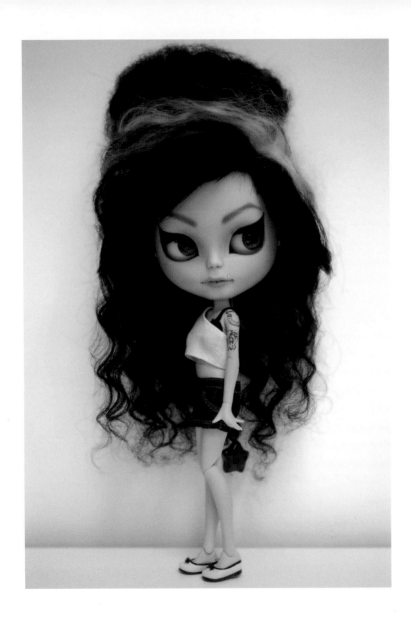

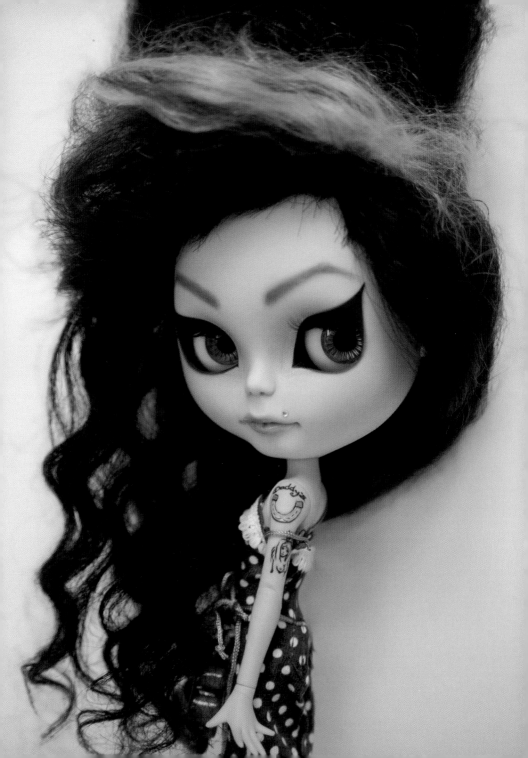

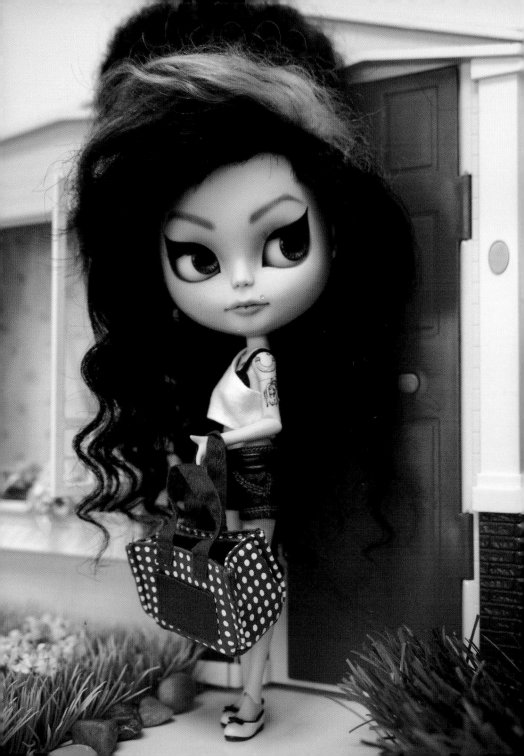

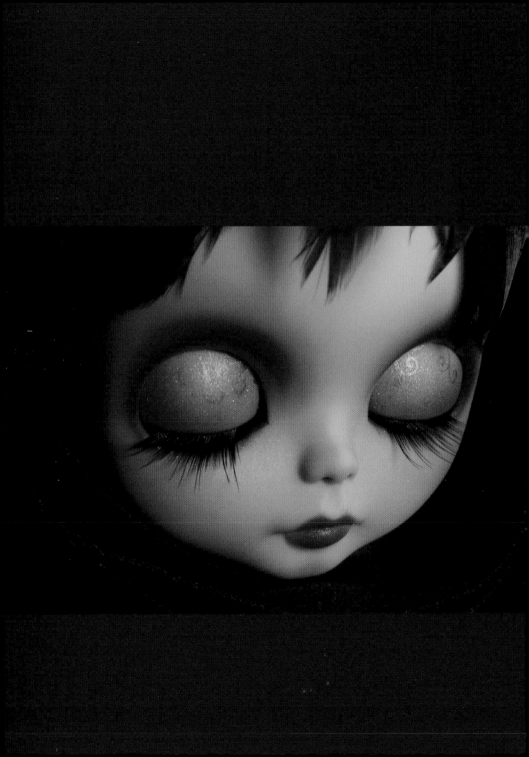

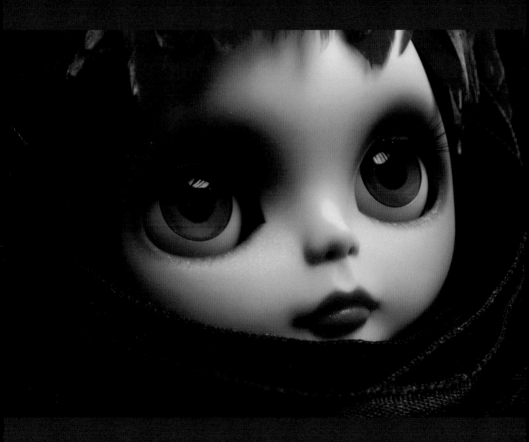

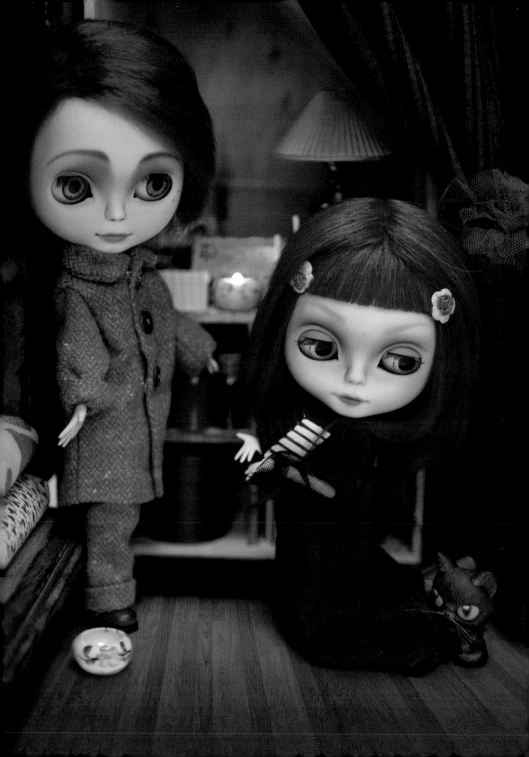

La Petite Sorcière

70 > 79

"Lisbeth and Edward are two characters based on and inspired by the tale "The Little Witch" (La Petite Sorcière) written by Sébastien Perez and illustrated by Benjamin Lacombe."

"Lisbeth y Edward son dos personajes basados e inspirados en el cuento "The Little Witch" (La Petite Sorcière) escrito por Sébastien Perez y con ilustraciones de Benjamin Lacombe".

Lisbeth
La petite sorcière

72 & 73

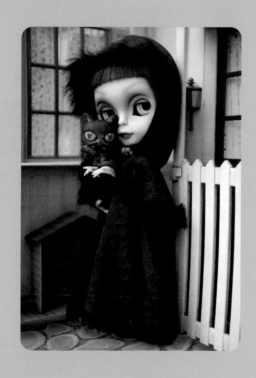

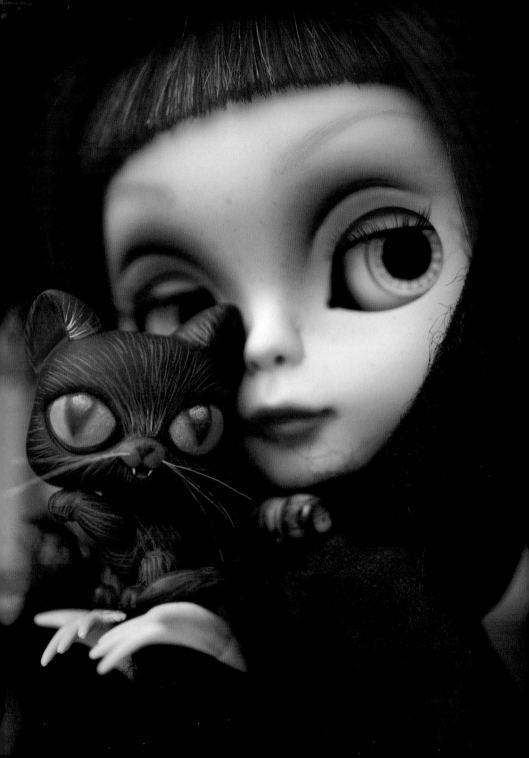

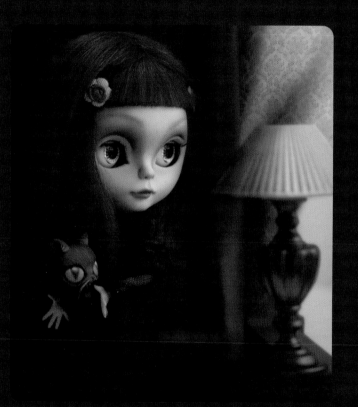

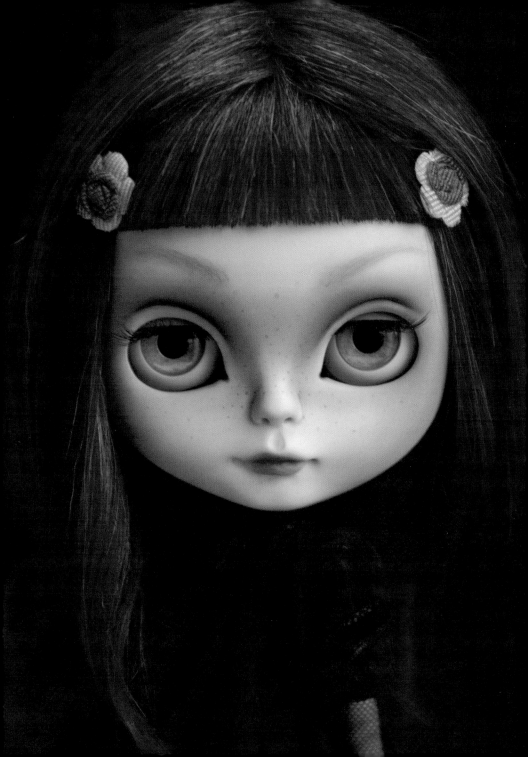

Edward

77

Background illustration courtesy of Benjamin Lacombe.

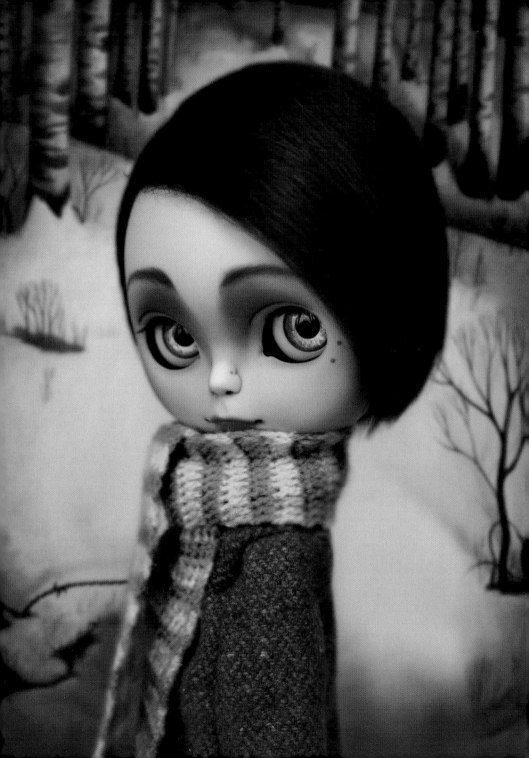

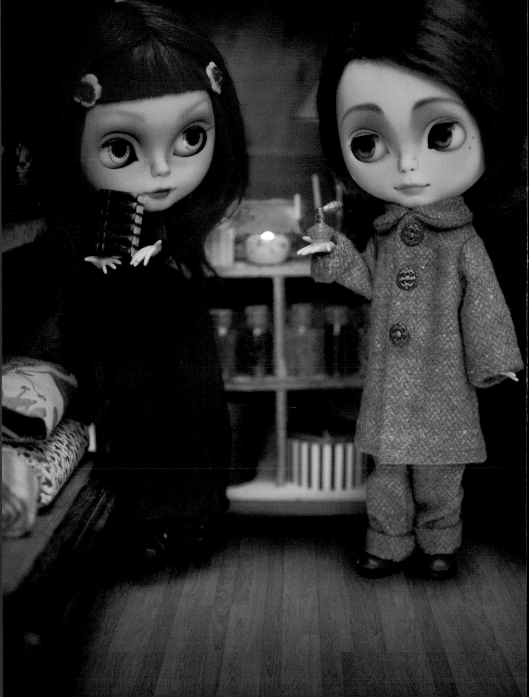

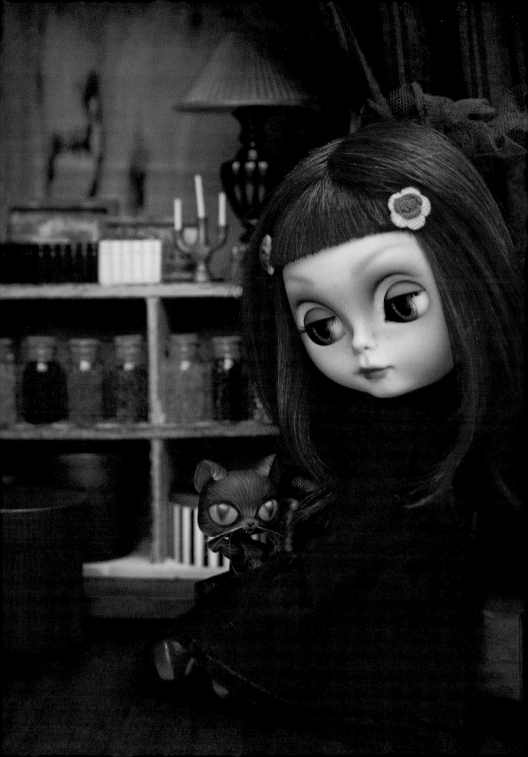

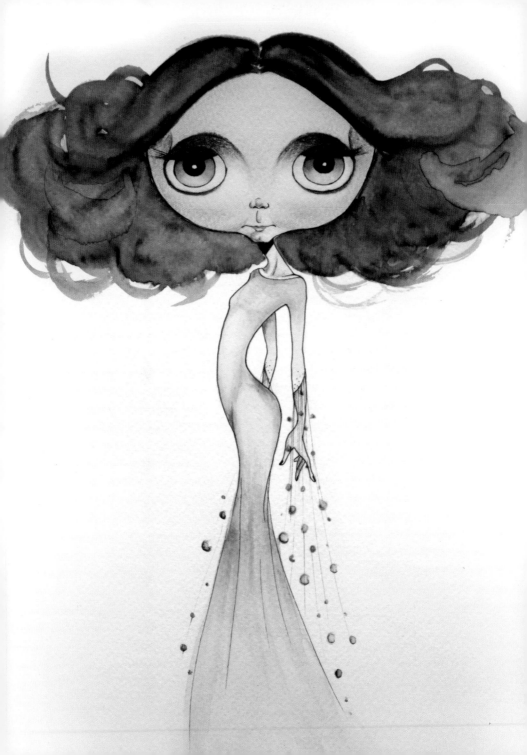

Character sketches.
Illustrations courtesy of J. Alberto Rodríguez.

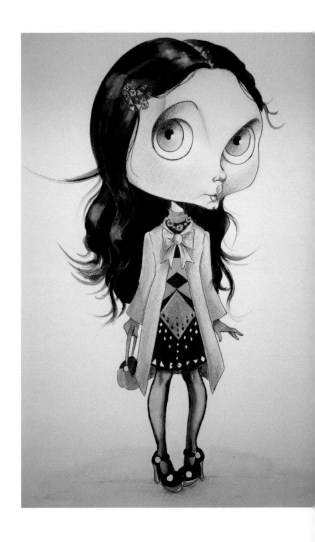

Melancholic
Couture

80

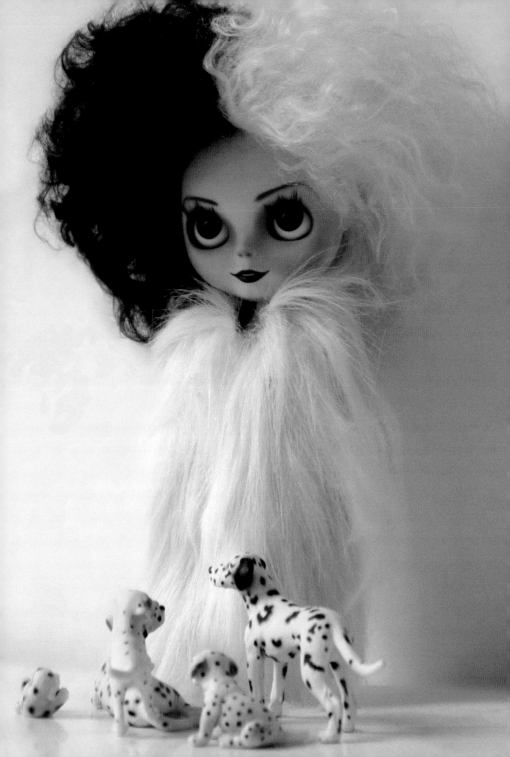

Cruella de Vil

82 > 85

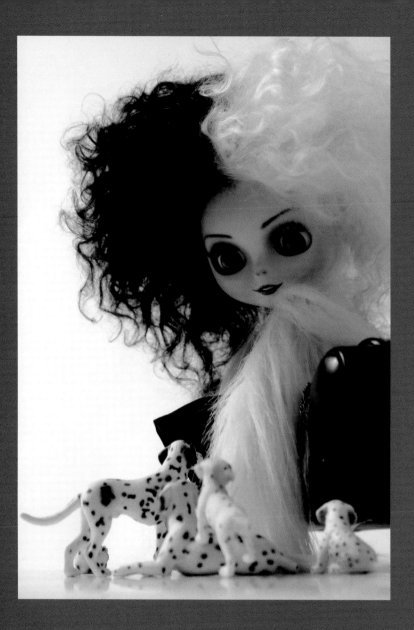

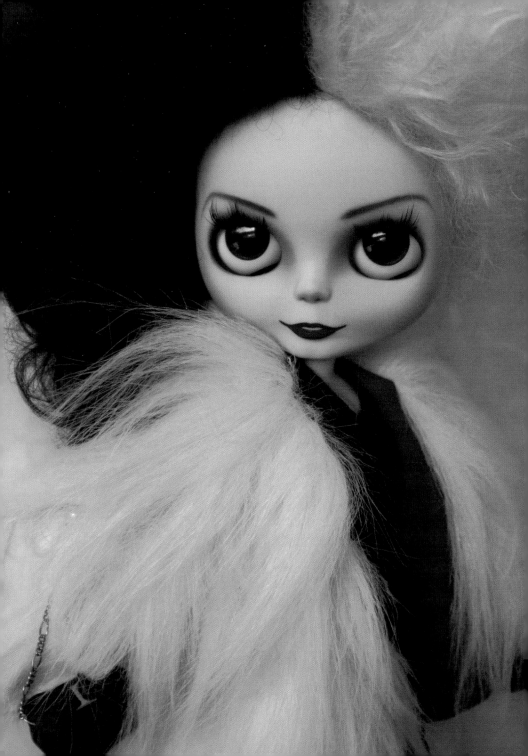

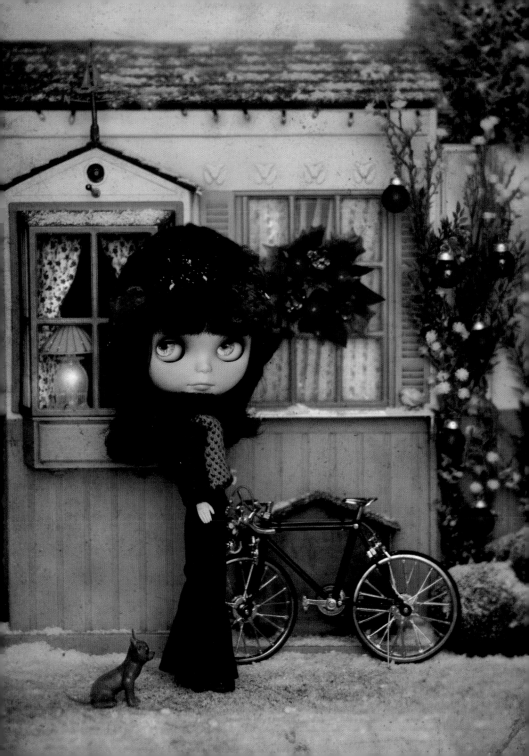

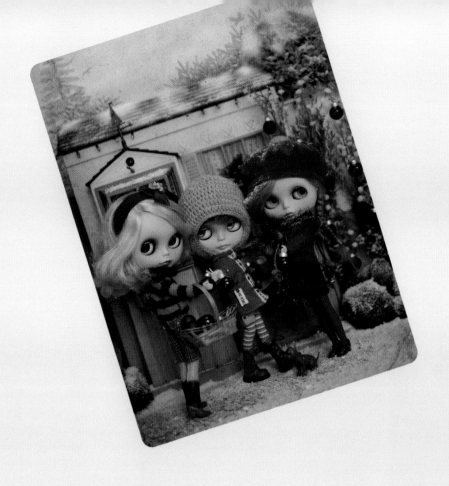

The Christmas Cards

86 > 91

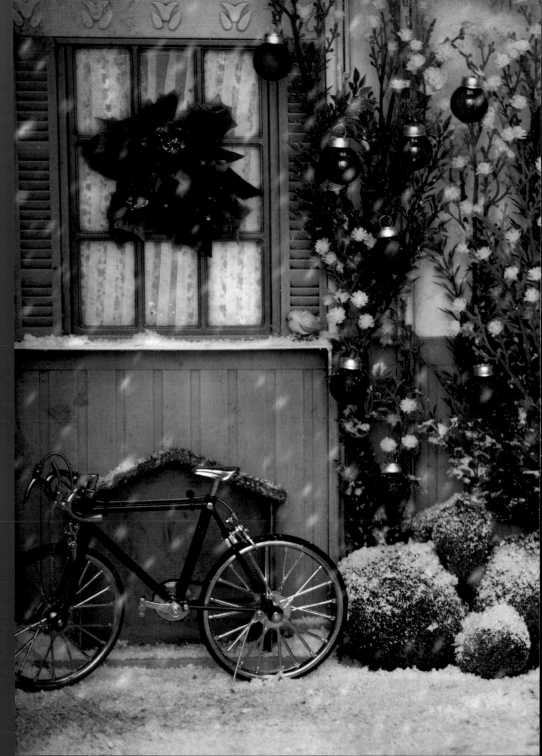

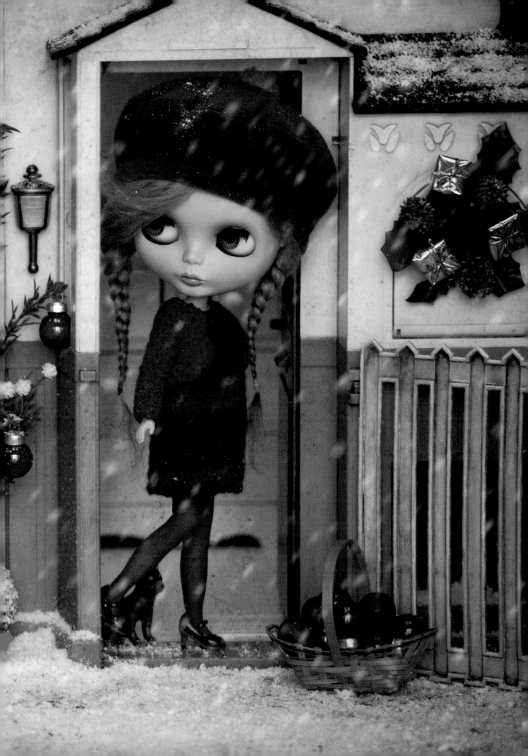

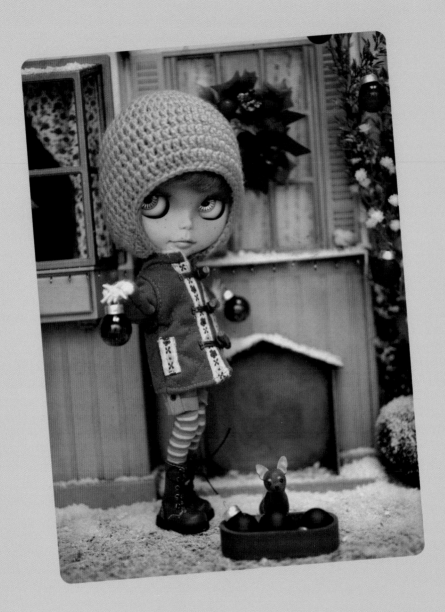

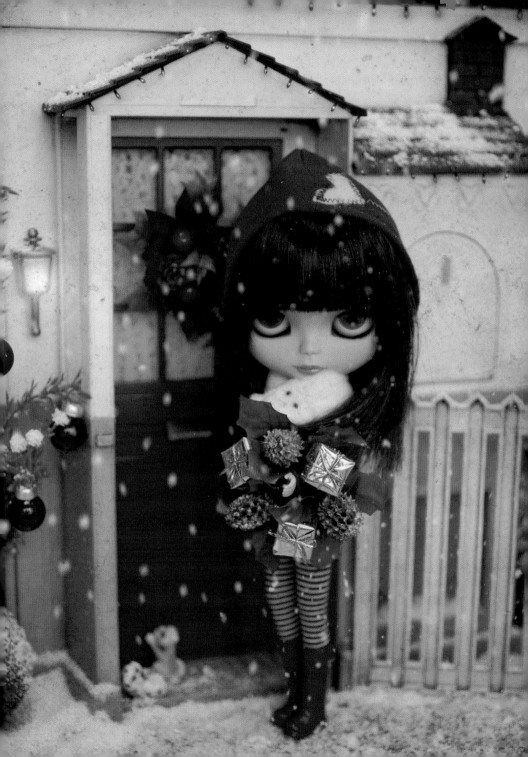

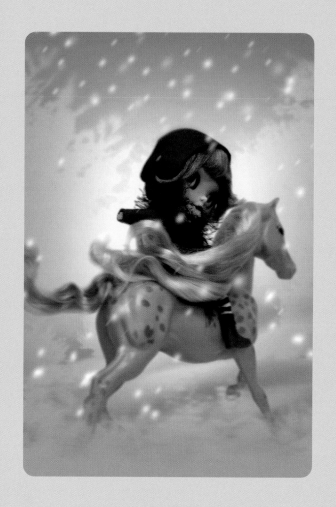

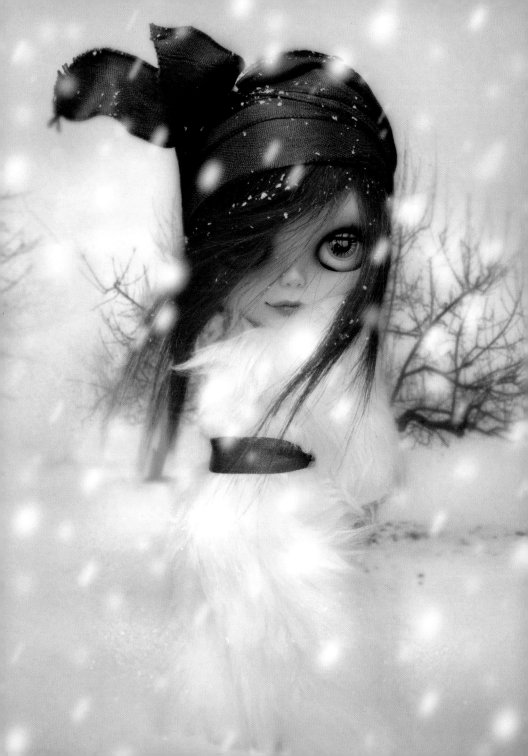

Snow Days
94 & 95

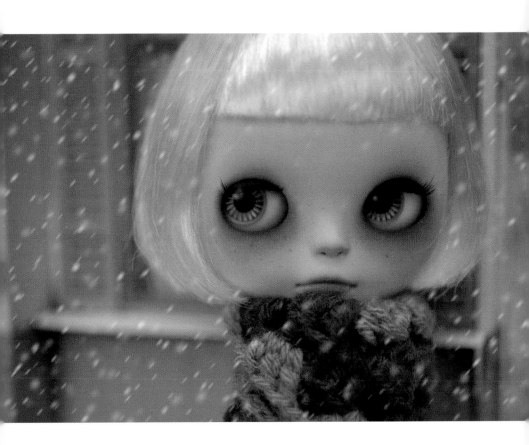

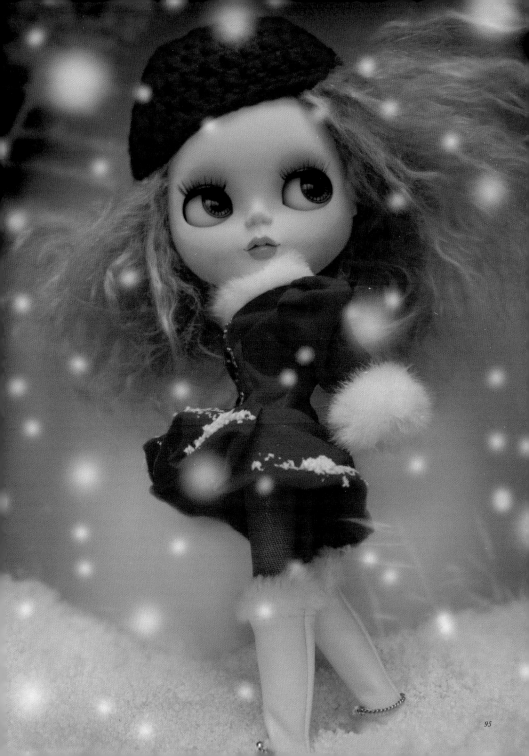

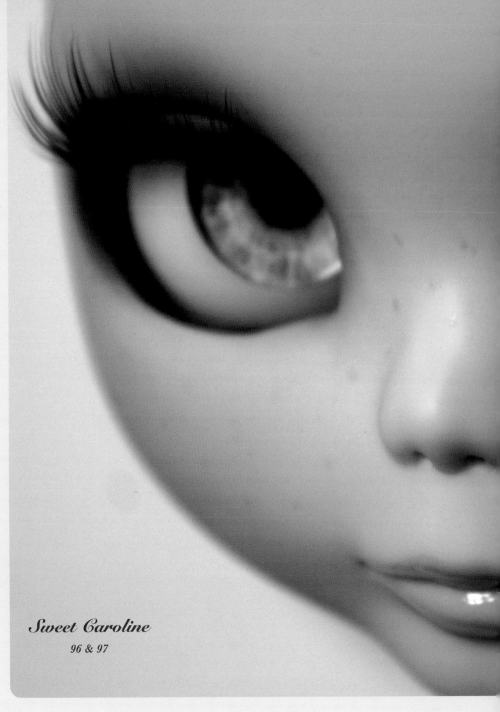

Sweet Caroline

96 & 97

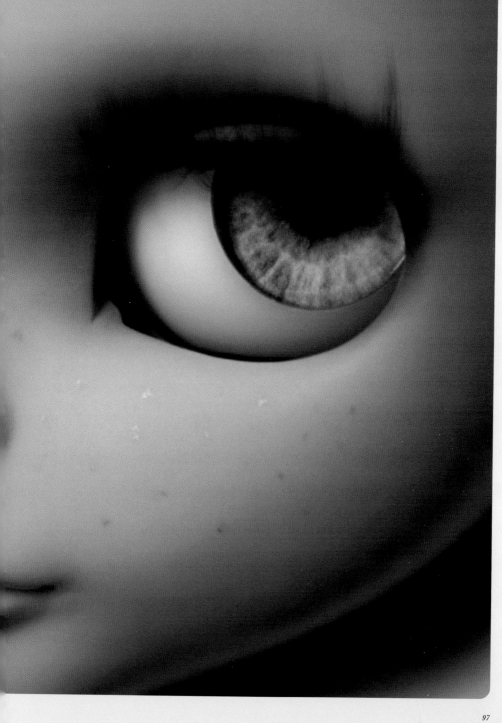

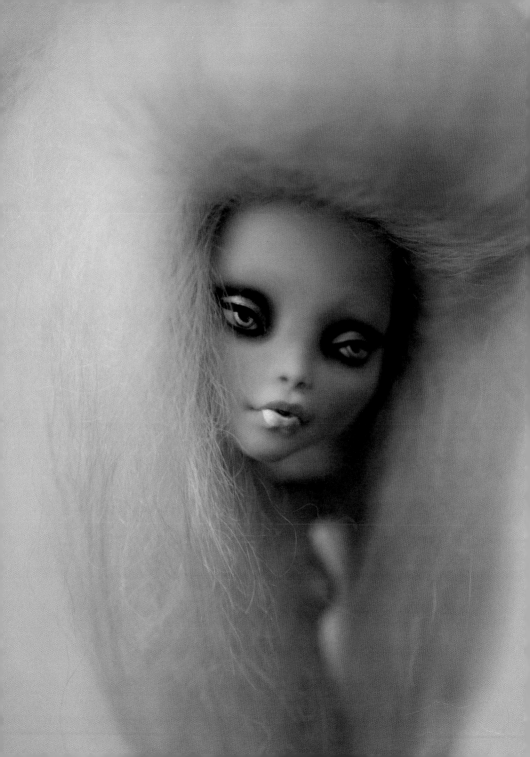

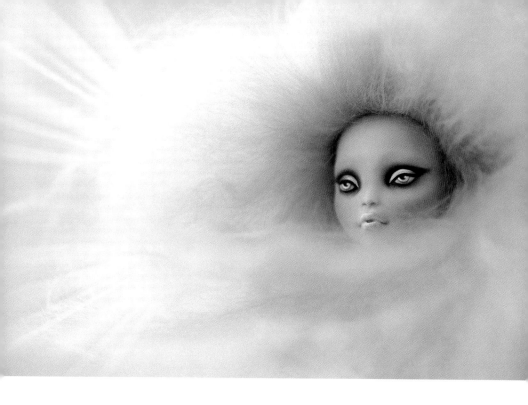

Cloud Girl

98 & 99

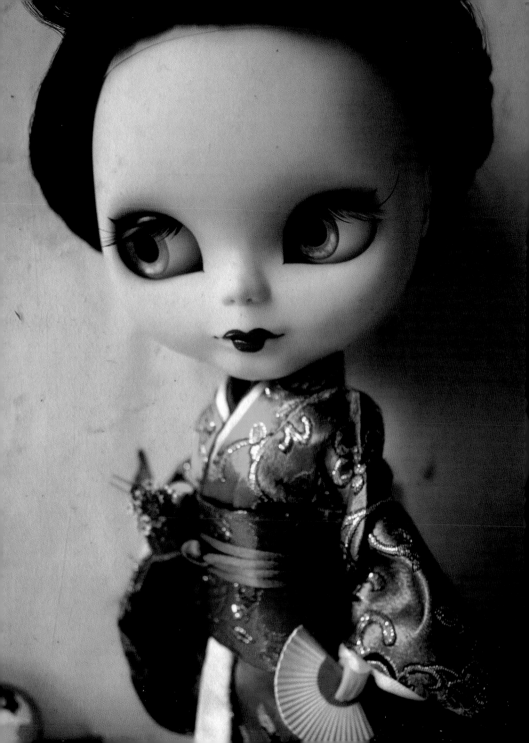

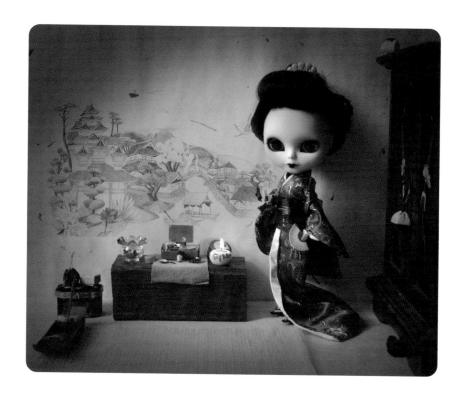

*"Sayuri is inspired by the novel and movie Memoirs of a Geisha, when
I first read the book and saw the movie I thought that Sayuri was a very special
character, full of strength and hope. I knew immediately I wanted to do
something inspired by that story."*

*"Sayuri está inspirada en la novela y la película Memorias de una Geisha, cuando leí el libro y vi
la película pensé que Sayuri era un personaje muy especial, lleno de fuerza y esperanza. Supe de
inmediato que quería hacer algo inspirado en esa historia".*

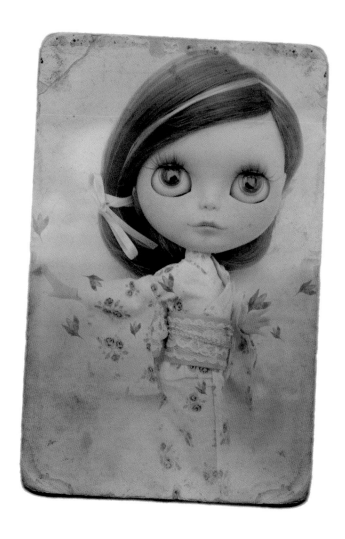

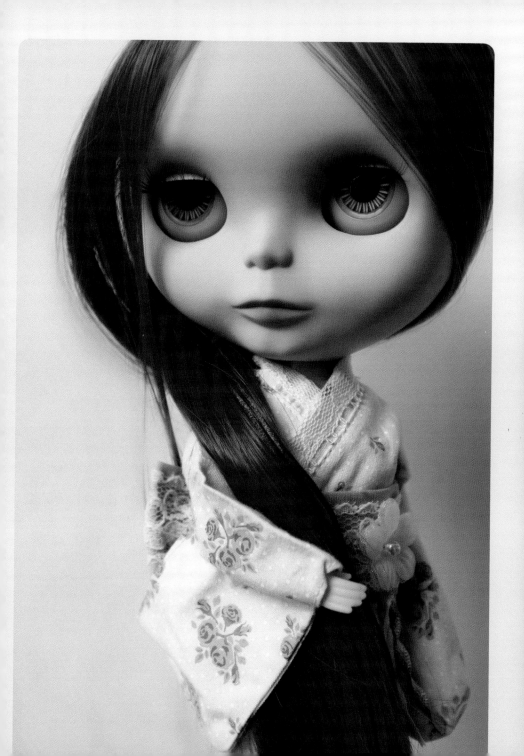

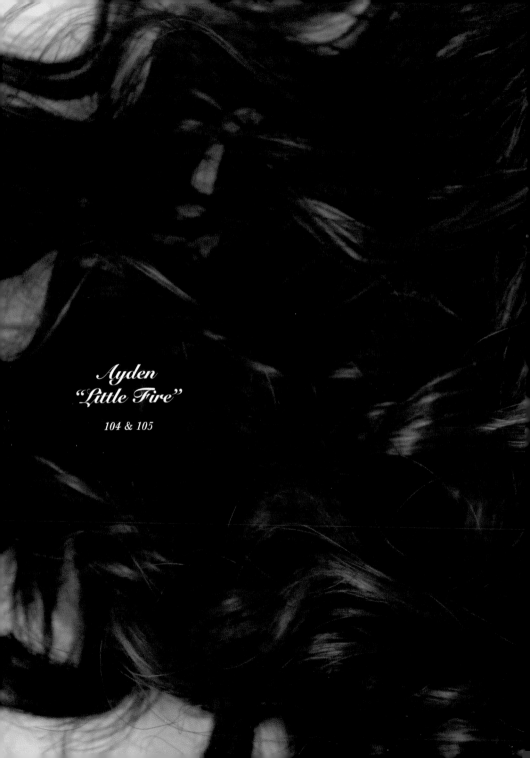

Ayden
"Little Fire"

104 & 105

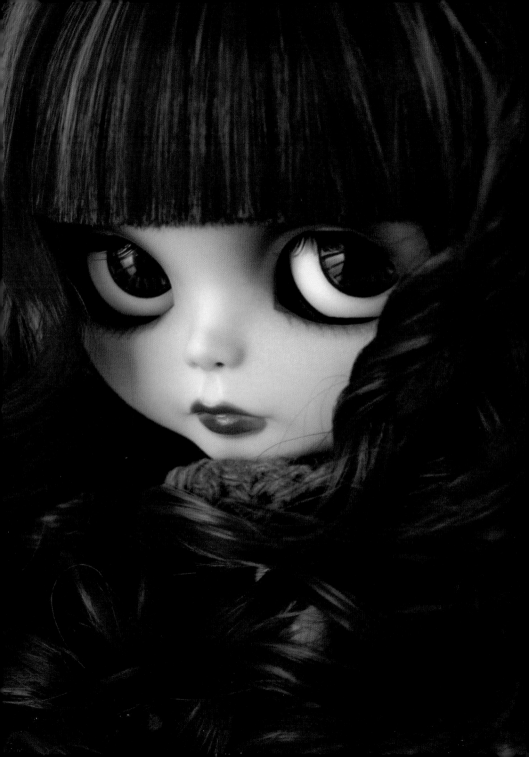

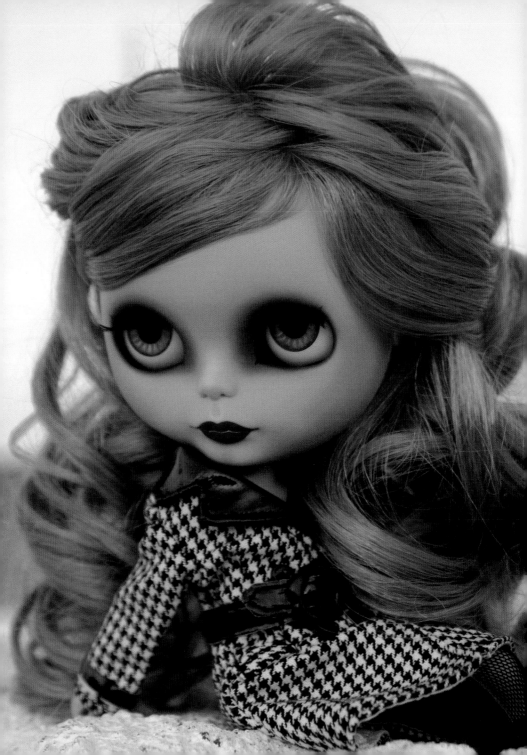

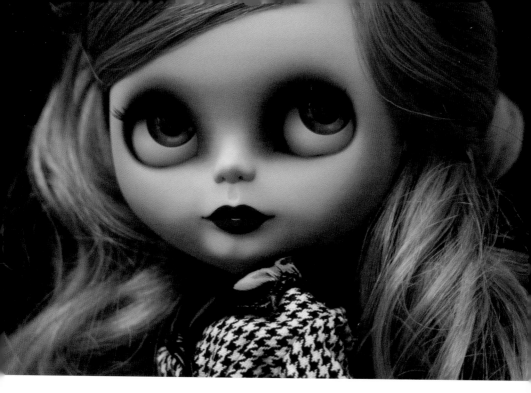

Parisienne

106 & 107

Emilie

108 > 115

"Emilie is based on the art of Gustav Klimt, and inspired by her beloved friend, lover, mate, partner, and muse Emilie Flögue, an avant-garde fashion designer. Emilie is my humble tribute to this great artist. Thanks to Alberto Rodríguez for his art and for creating the very first drawing of this character, and to my sisters for the amazing work done with the outfits."

"Emilie está basada en el arte de Gustav Klimt e inspirada en su querida amiga, amante, compañera, pareja, su musa Emilie Flögue, una diseñadora de moda vanguardista. Emilie es mi humilde tributo a este gran artista. Gracias a J. Alberto Rodríguez por su arte creando el primer dibujo de este personaje y gracias a mis hermanas por el maravilloso trabajo realizado con el vesturario".

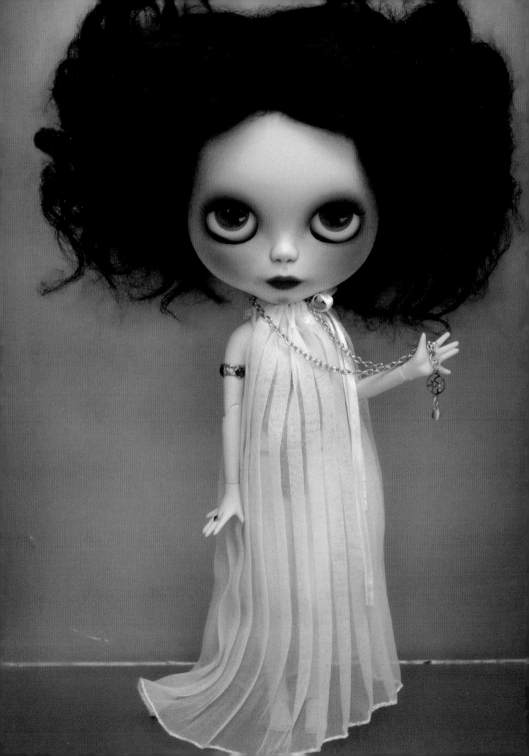

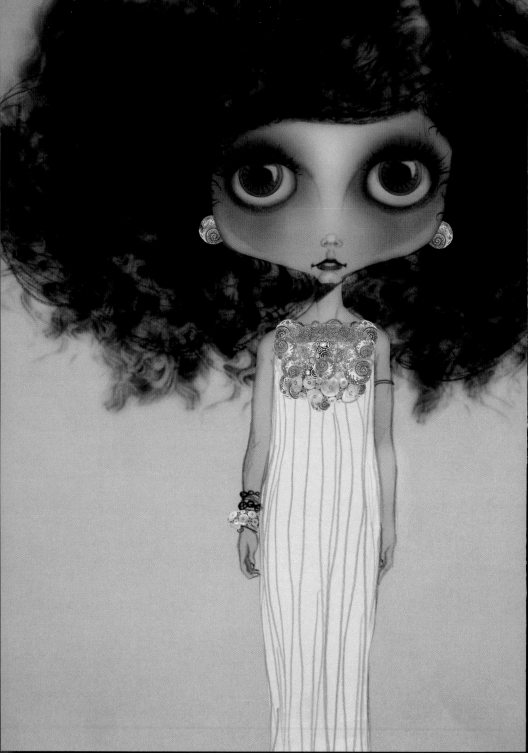

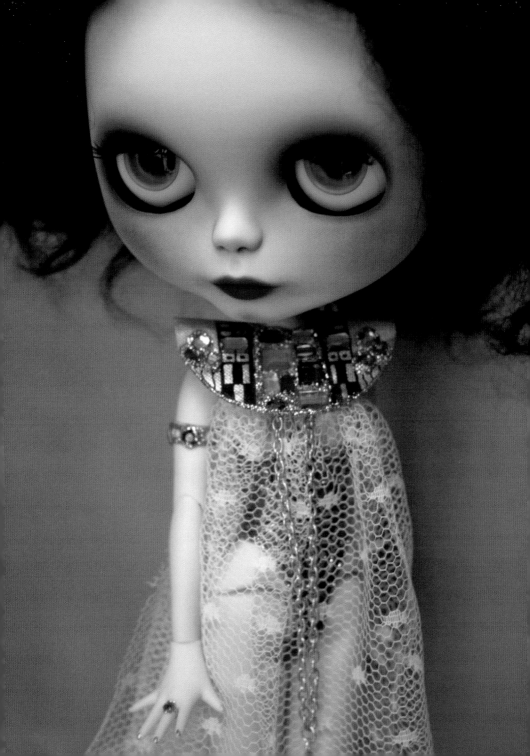

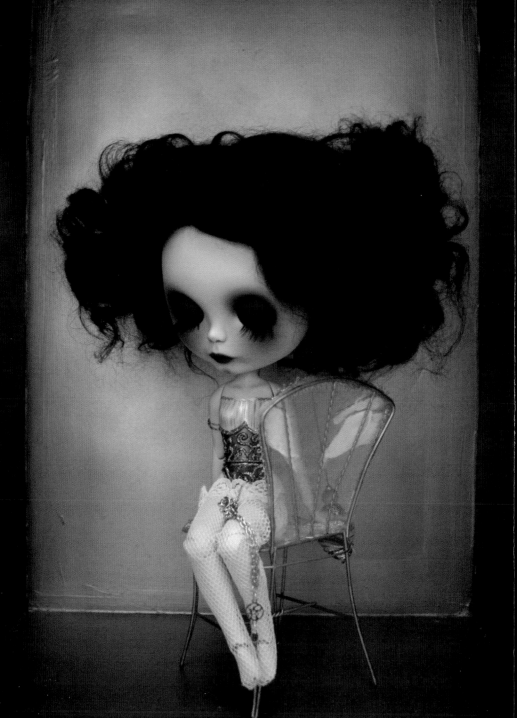

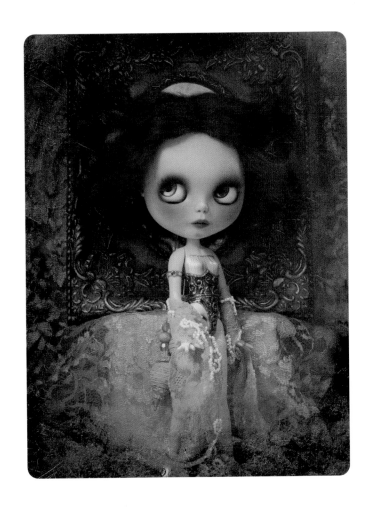

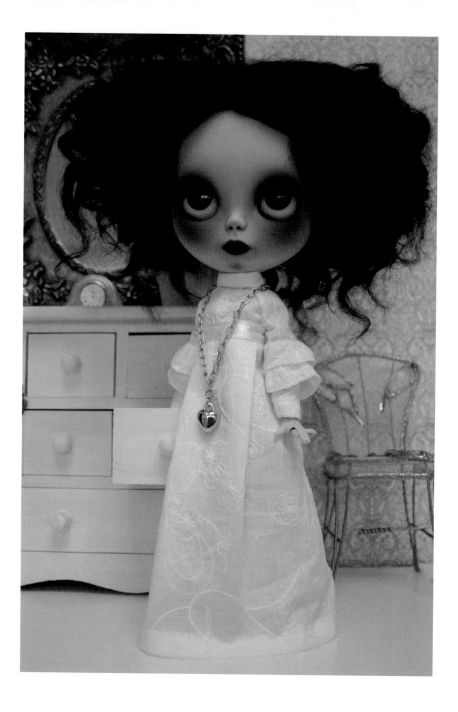

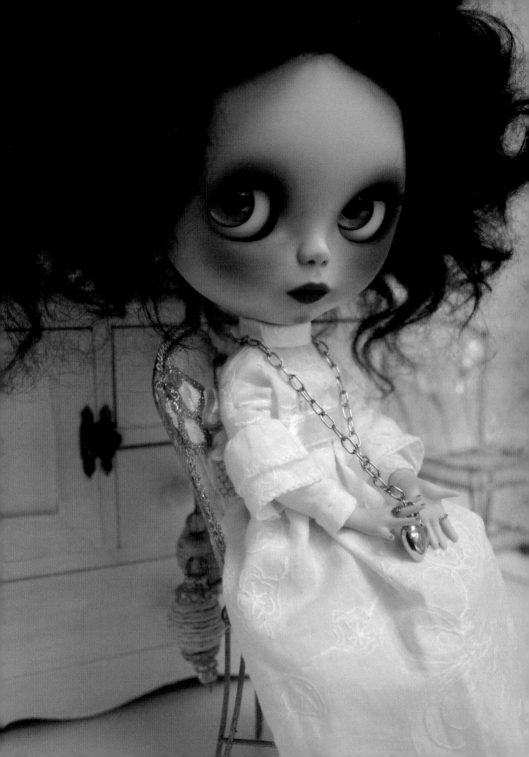

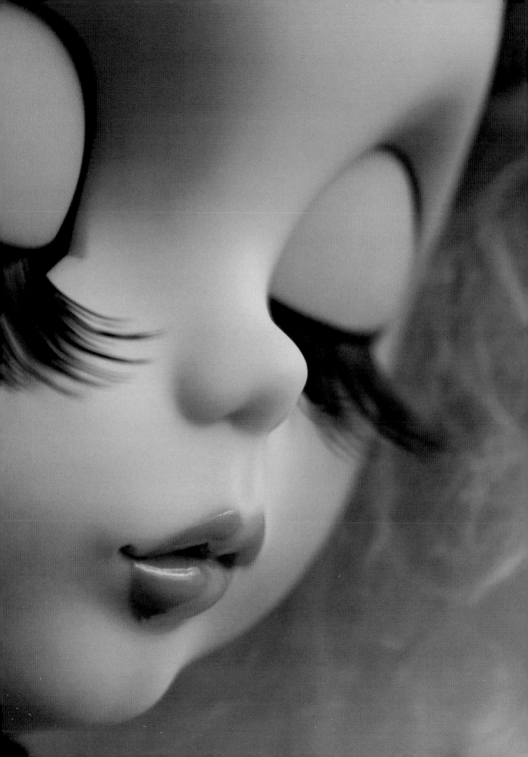

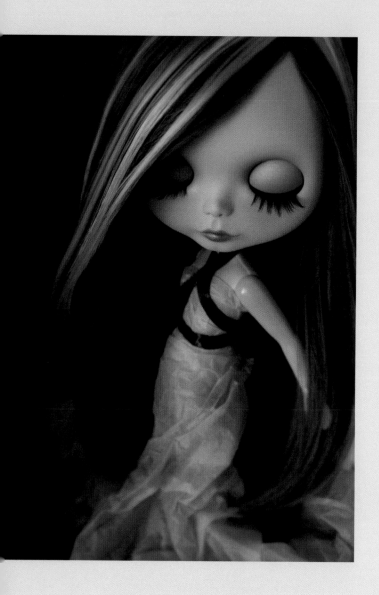

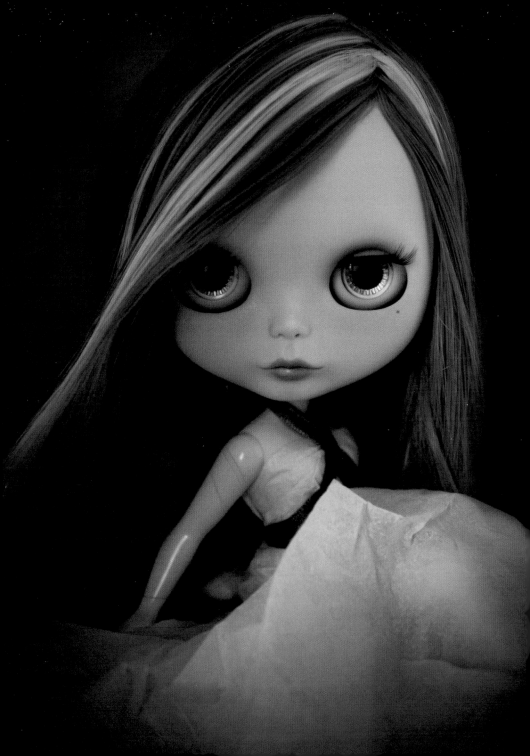

Bellasol
120 & 121

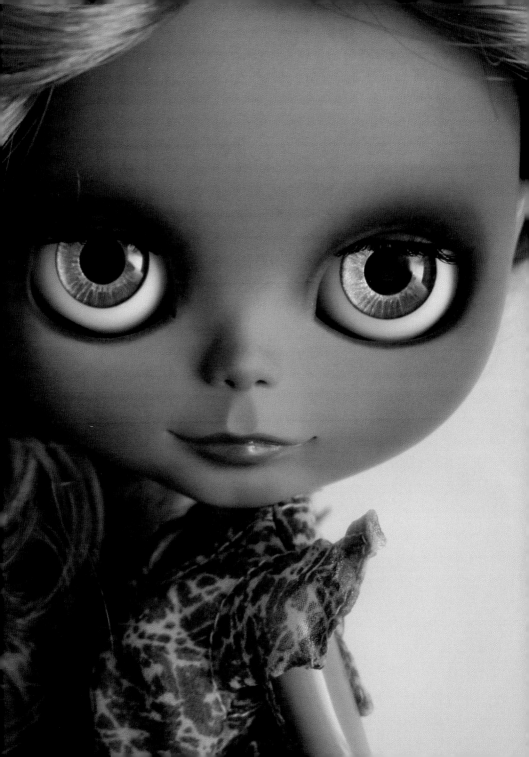

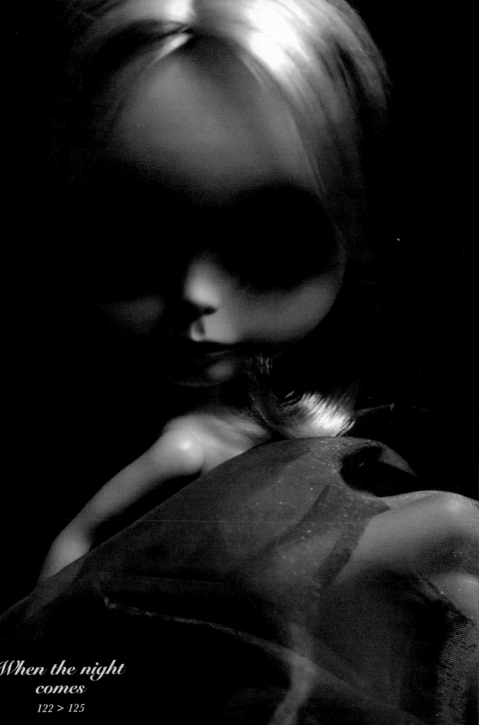

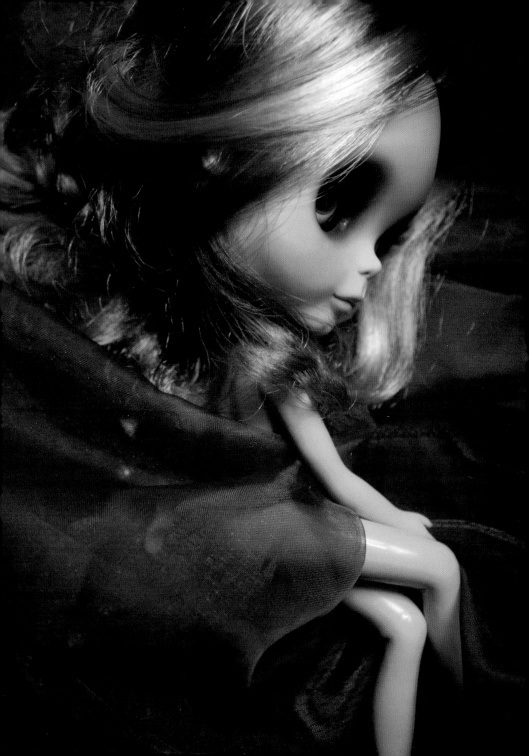

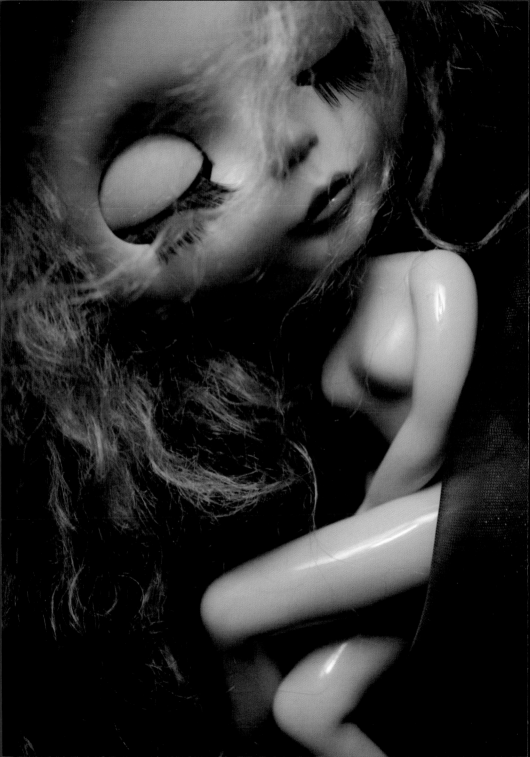

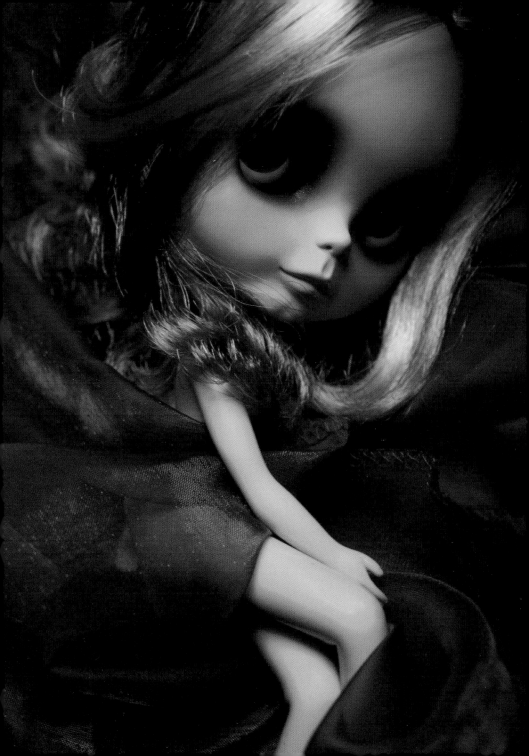

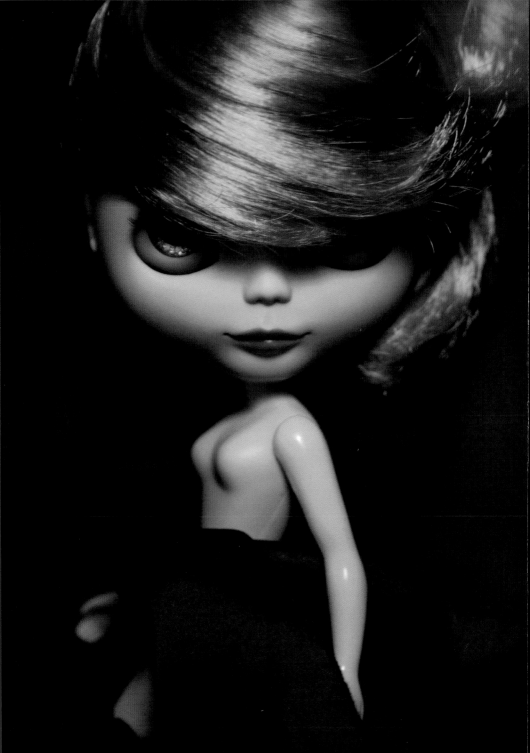

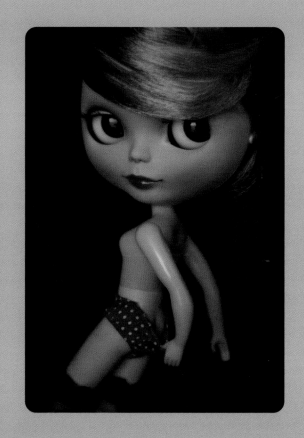

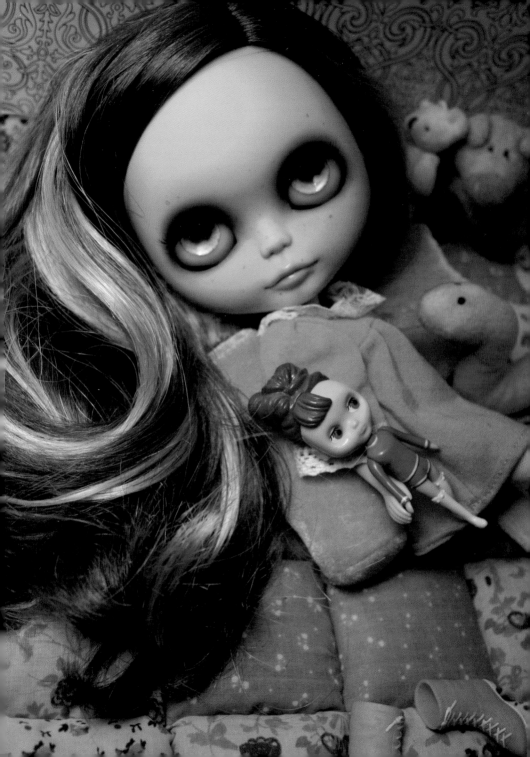

The White Rabbit

131

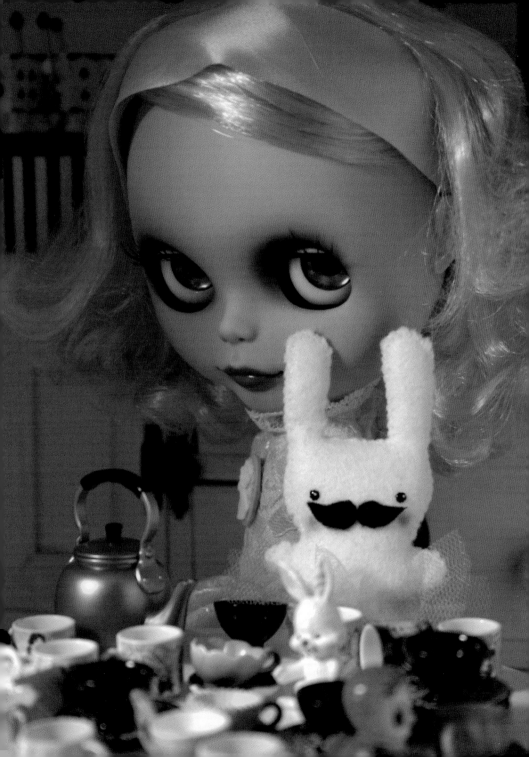

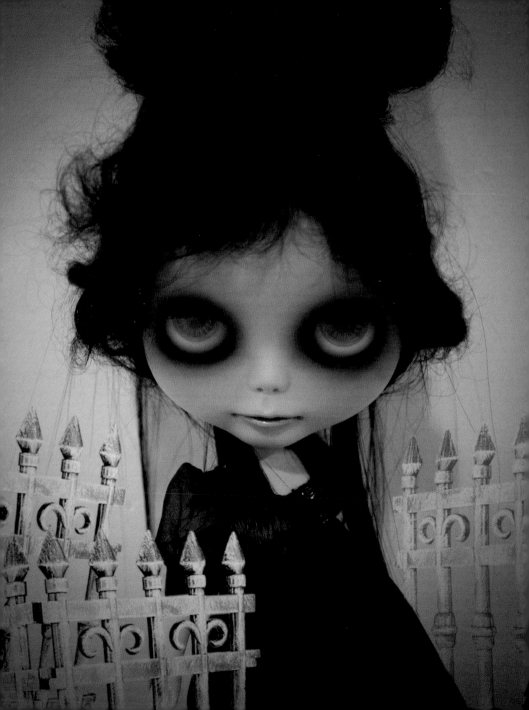

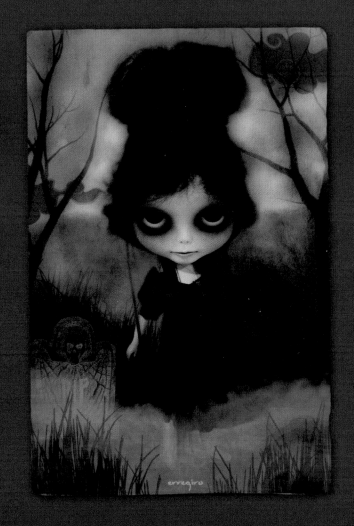

Lydia
from Beetlejuice
132 & 133

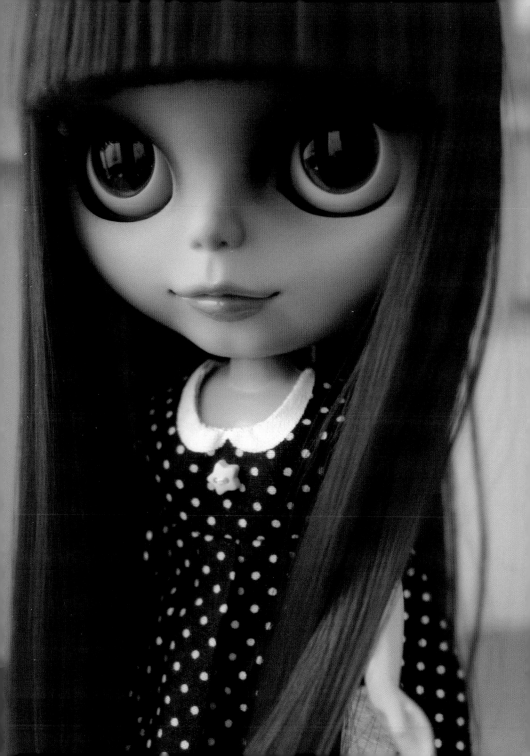

Before I leave
134

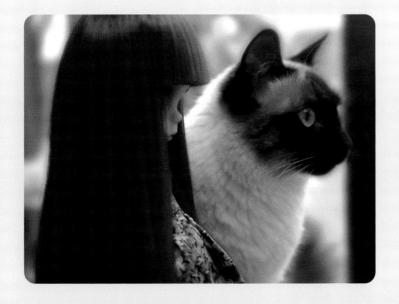

Did you see
that?
135

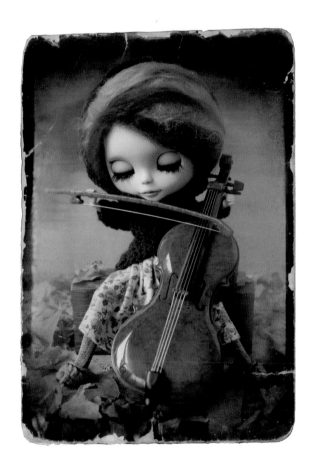

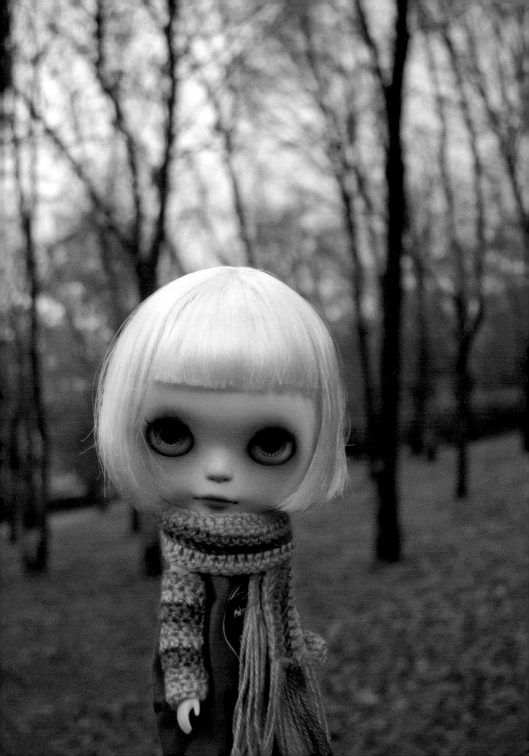

The
Boudoir

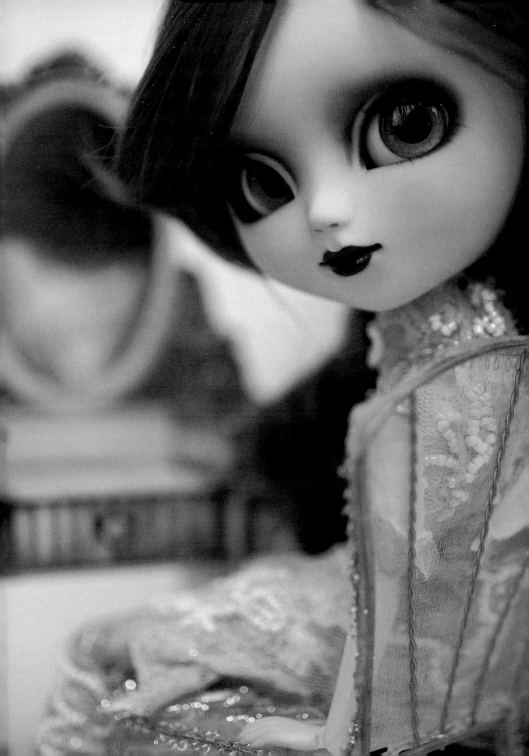

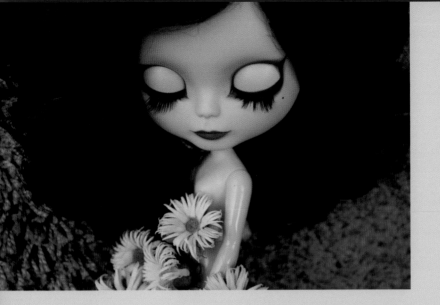

Dita von Teese

140 & 141

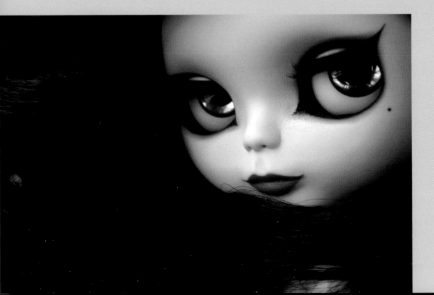

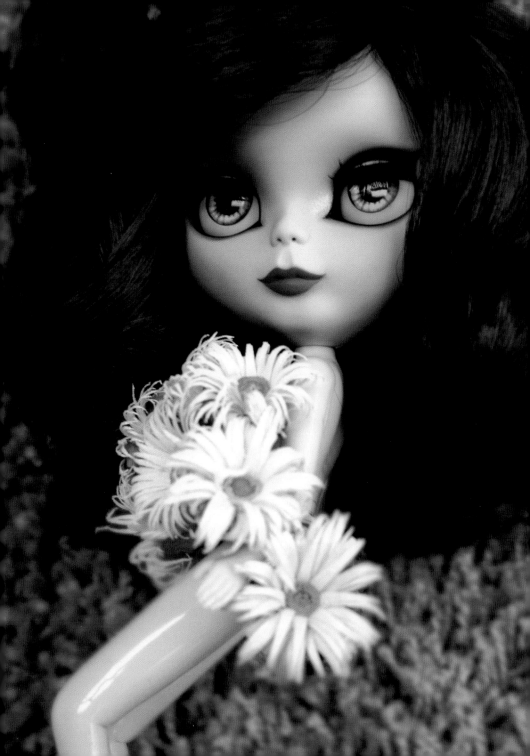

Brigitte Bardot

142 > 145

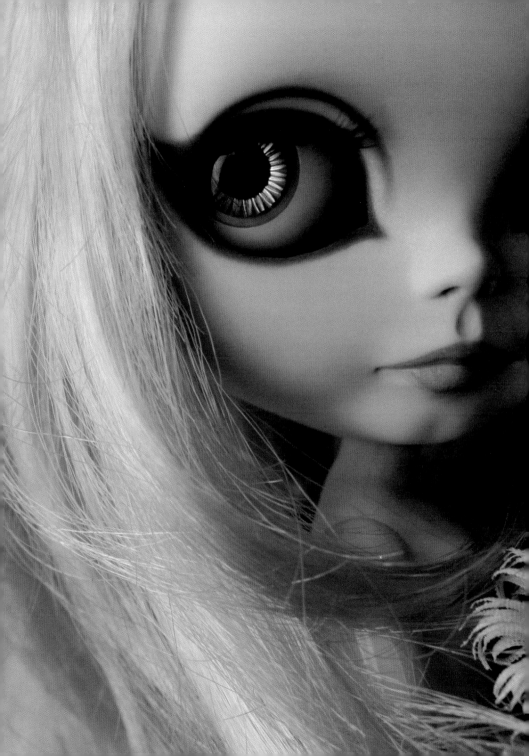

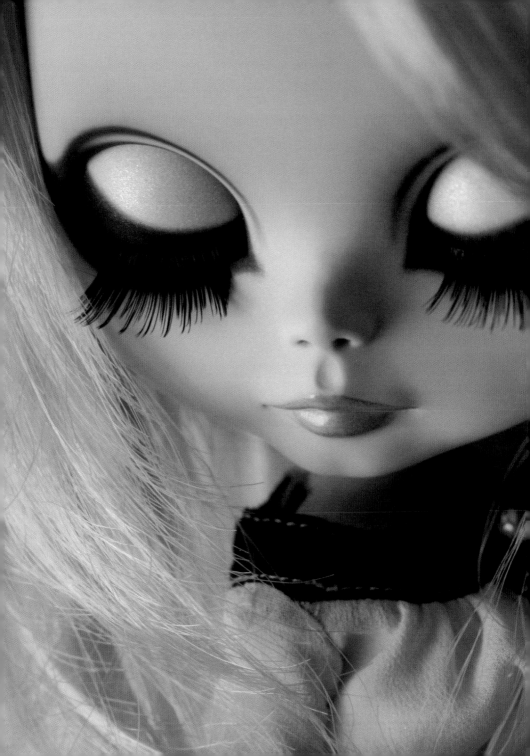

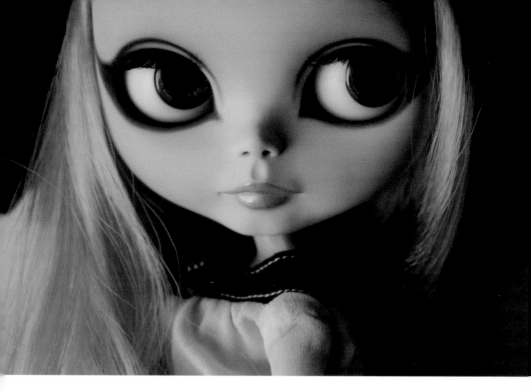

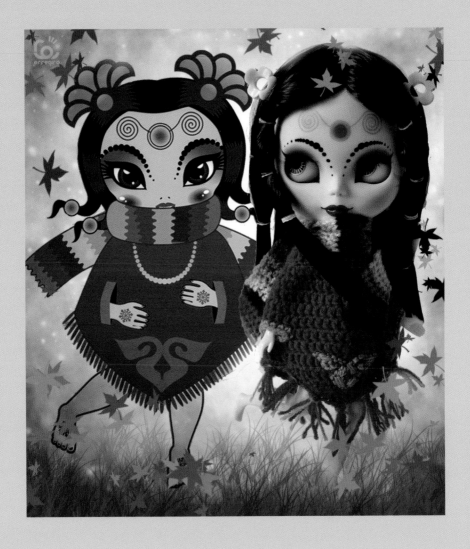

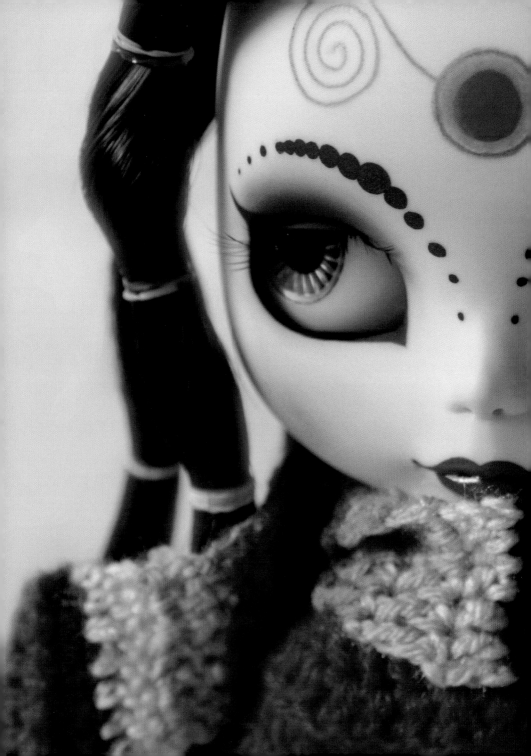

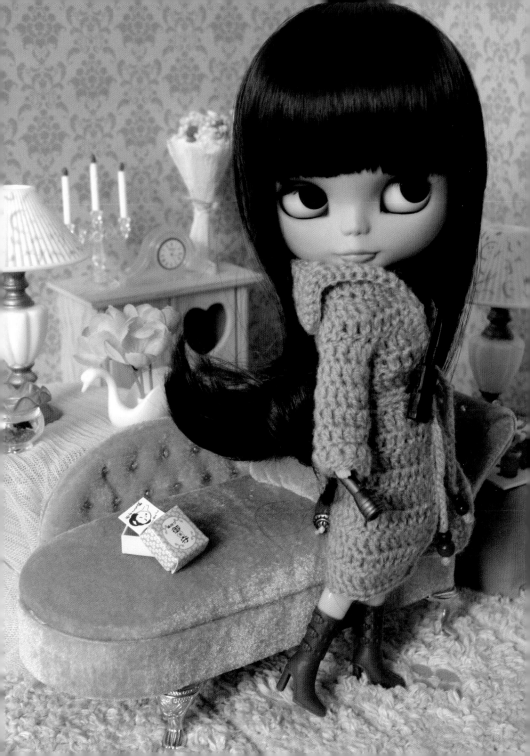

Tina
**Private
investigator**

148 & 149

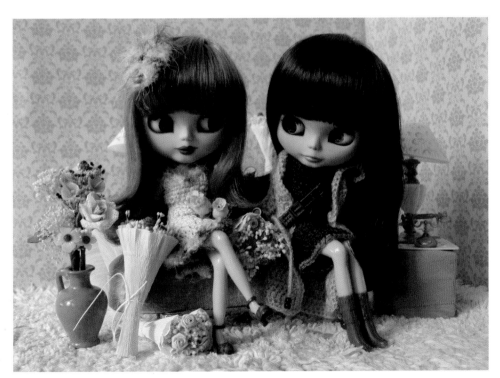

60's Style

151

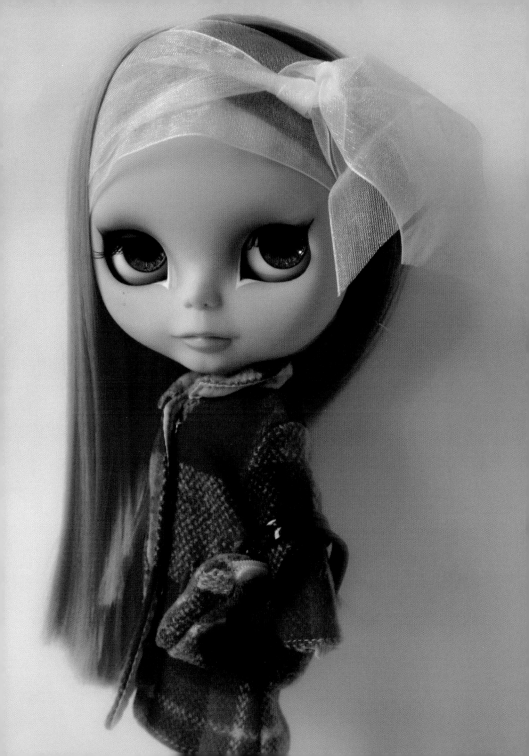

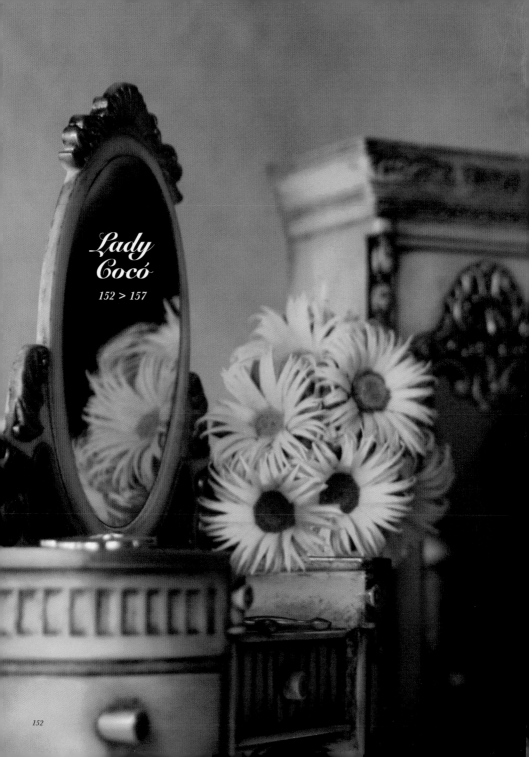

Lady
Cocó

152 > 157

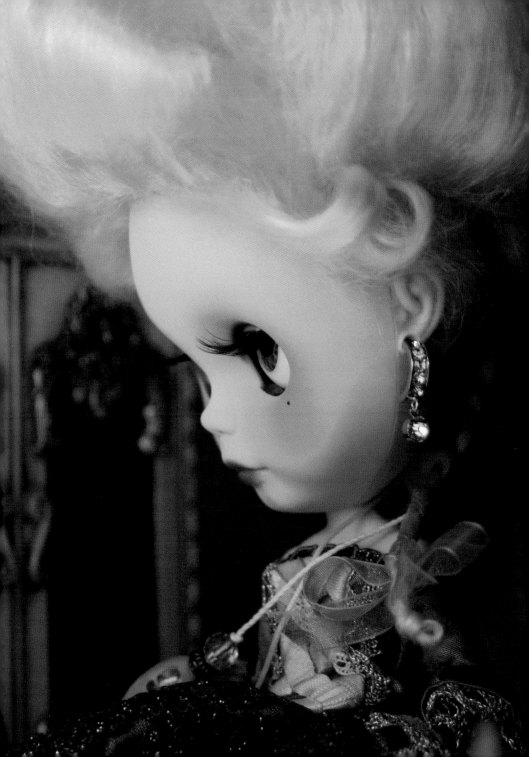

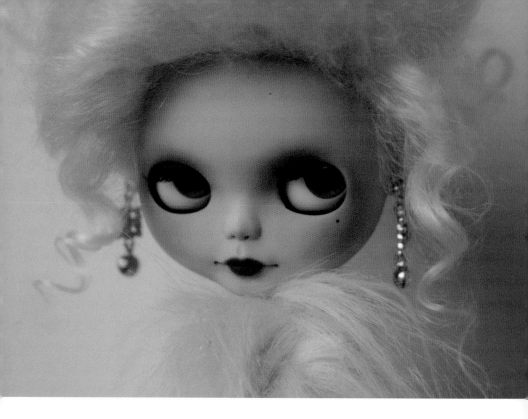

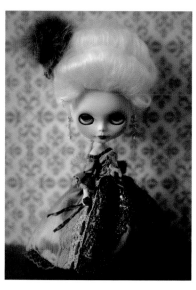

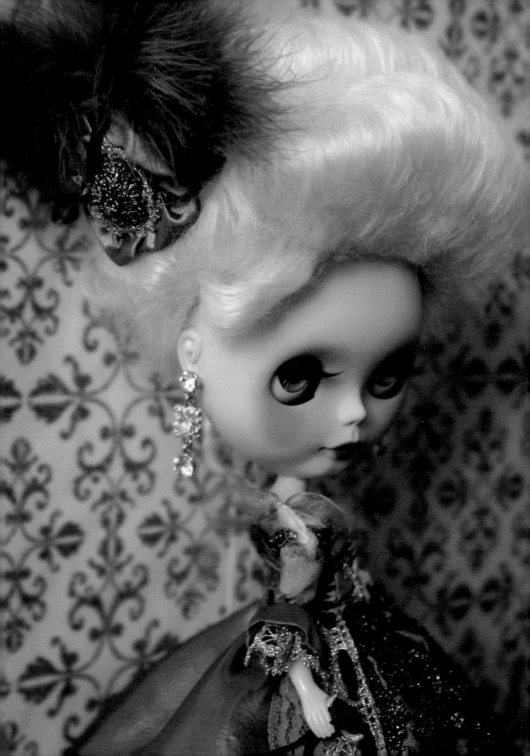

"Lady Cocó is based on female artists from the 18th-century art movement called Rococo. There are many women artists from that age whose work never appear on art books just because of being women, ignoring the quality of their paintings. Lady Cocó is my tribute not only to all the artists who have been forgotten for a long time, but a tribute to women."

"Lady Cocó está inspirada en las artistas femeninas del movimiento artístico del siglo dieciocho llamado Rococó. Hay muchas mujeres artistas de esa época cuyos trabajos nunca fueron publicados en los libros de arte simplemente por ser mujeres, ignorando la calidad de sus pinturas. Lady Cocó es mi pequeño homenaje a todas aquellas artistas que fueron olvidadas durante tanto tiempo, un homenaje a las mujeres".

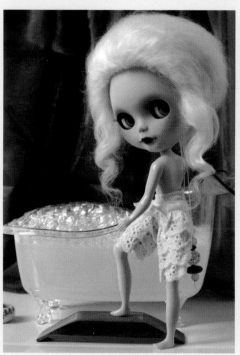
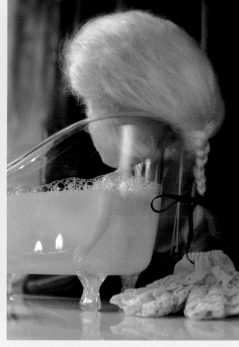

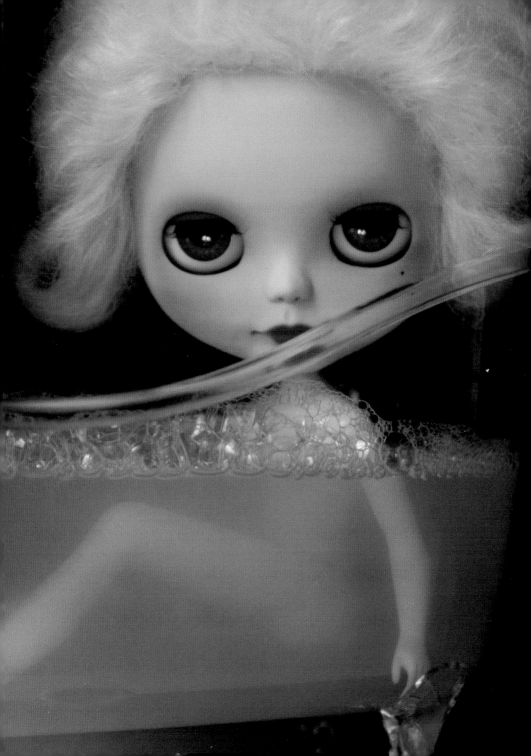

Janet

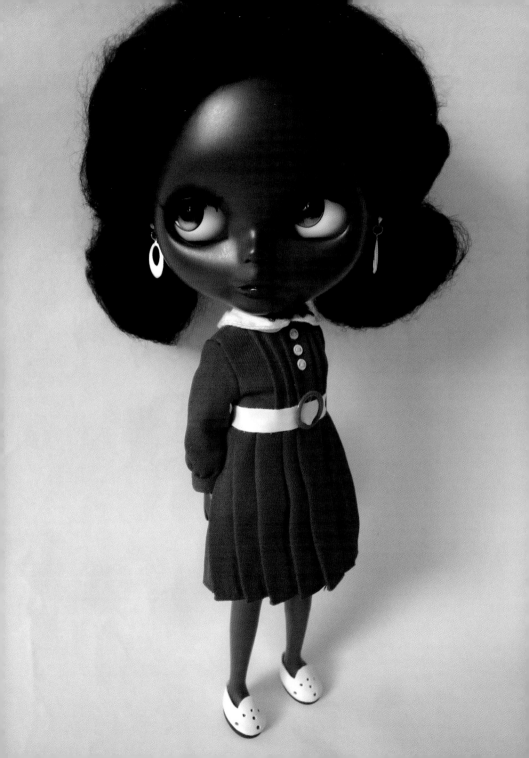

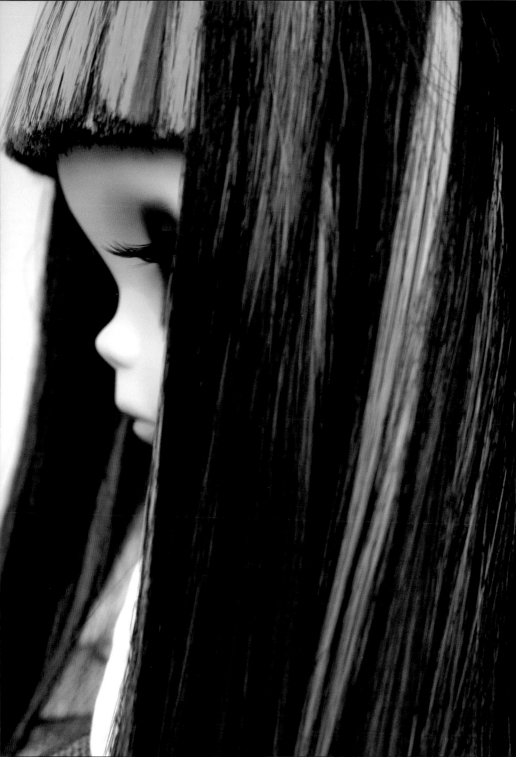

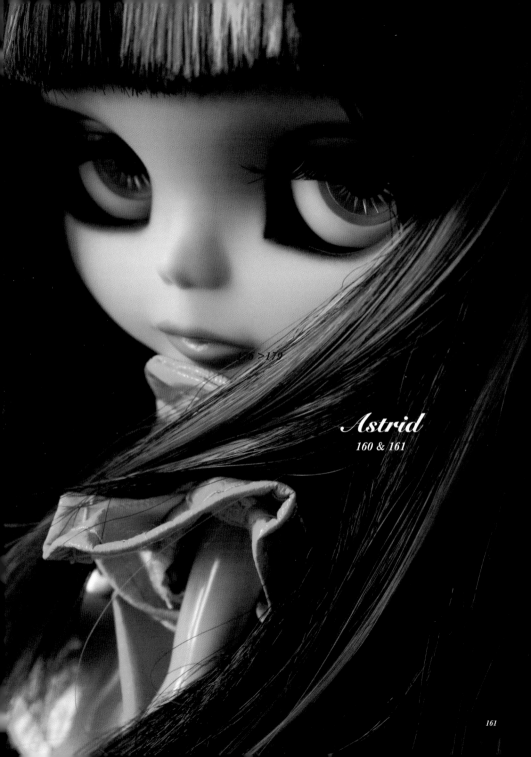

126 >179

Astrid
160 & 161

Miss
Wolf
162 & 163

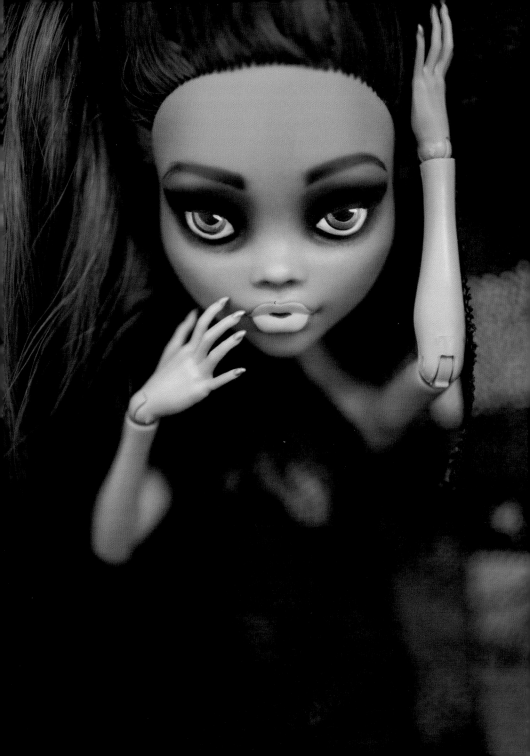

Oops!

165

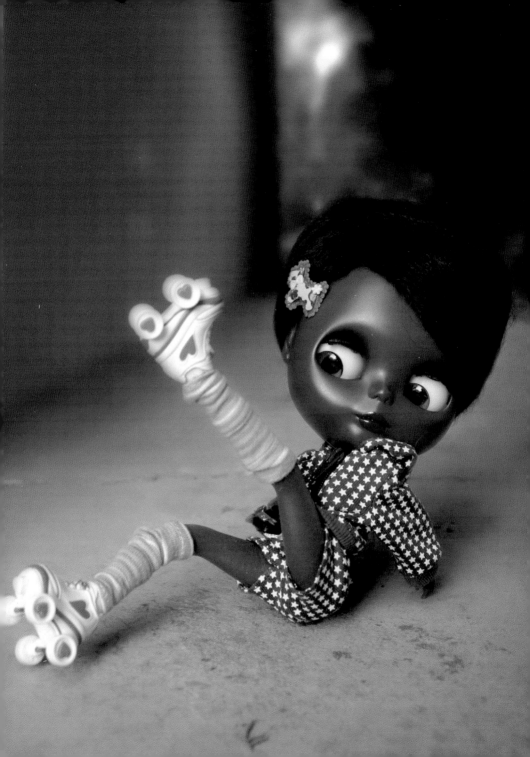

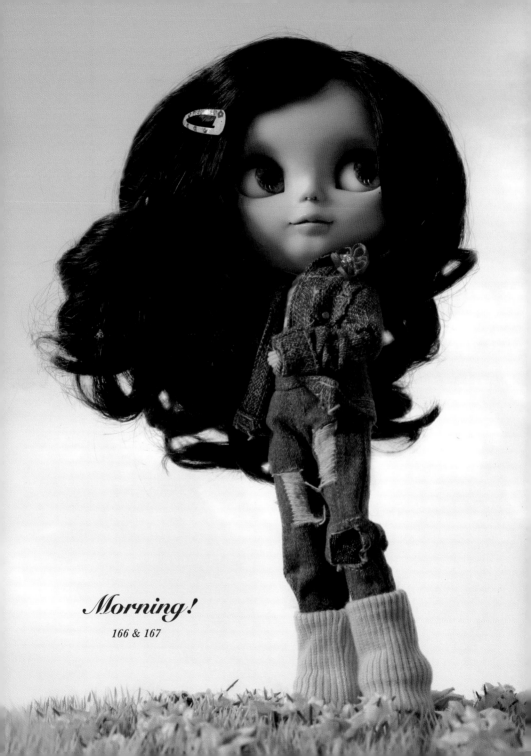

Morning!

166 & 167

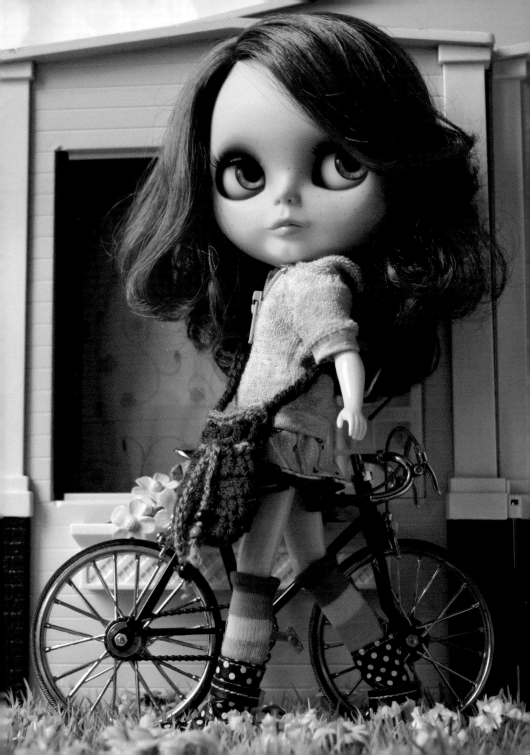

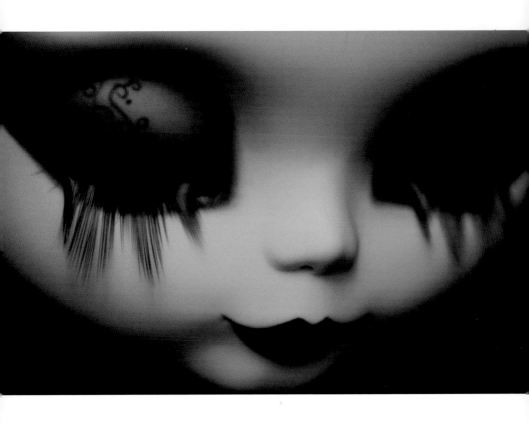

The
Gothic Ride

168 & 169

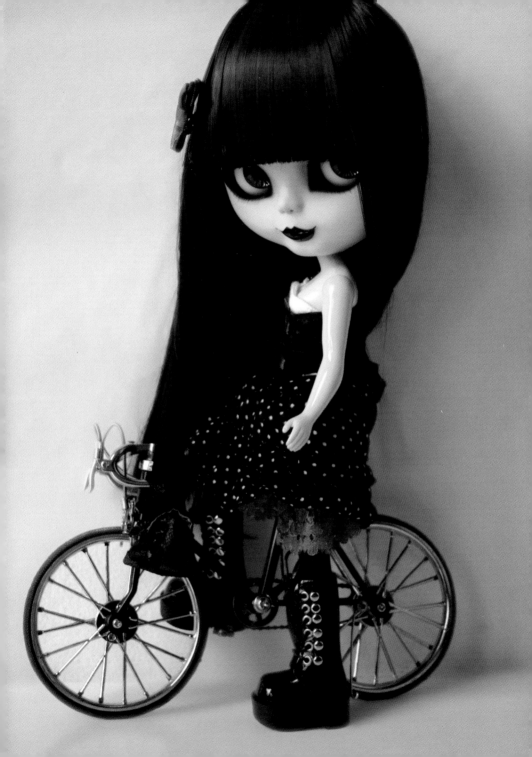

A Diva's wish

171

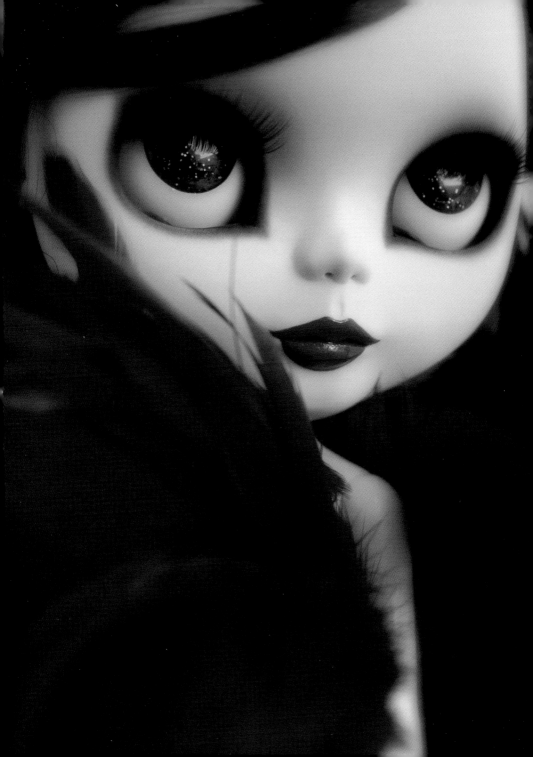

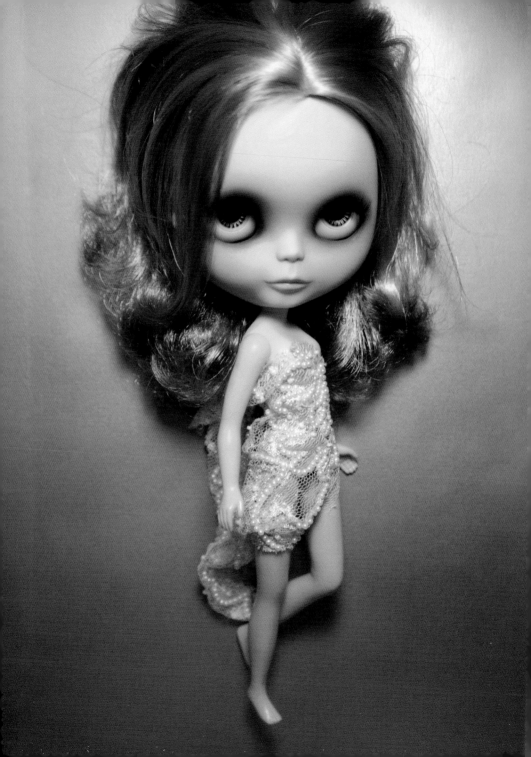

My own space

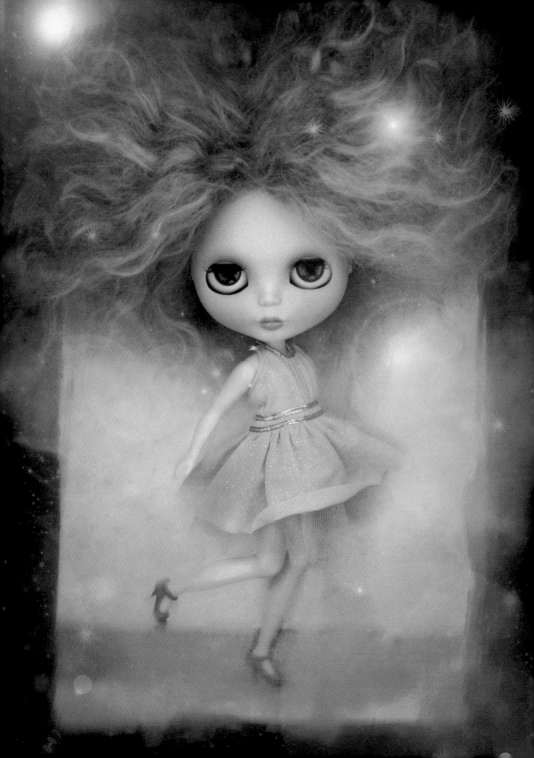

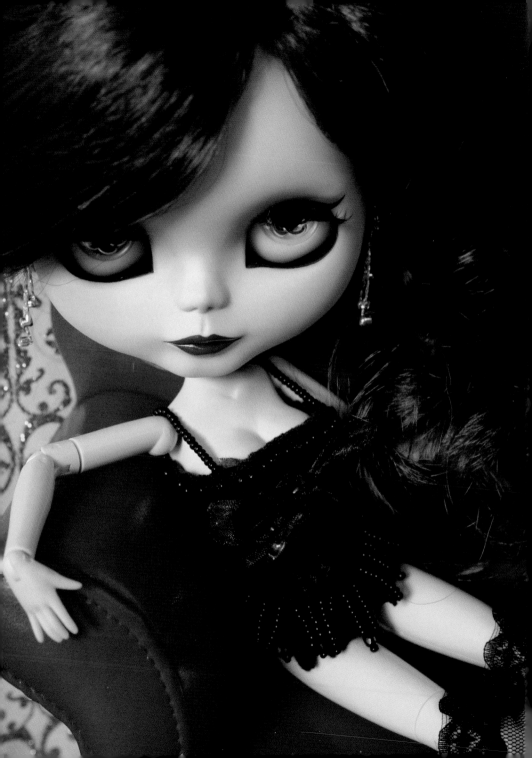

Satine
from Moulin Rouge
176 >179

"Based on the character played by Nicole Kidman in the movie Moulin Rouge."
"Basada en el personaje que interpreta Nicole Kidman en la película Moulin Rouge".

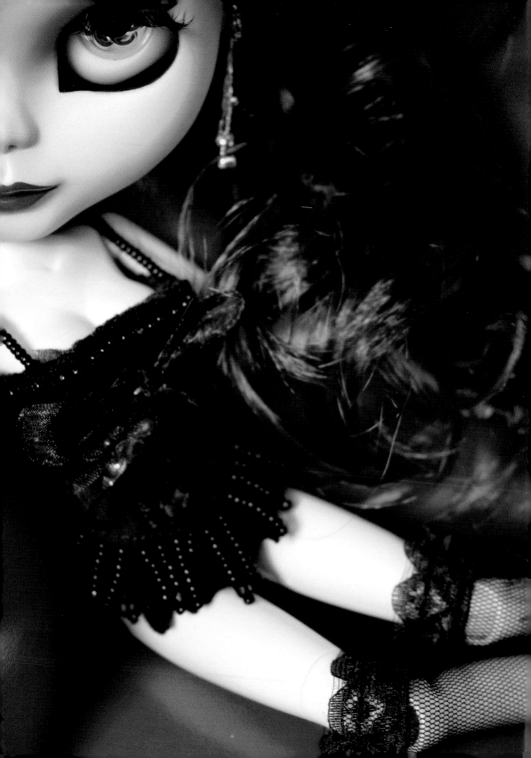

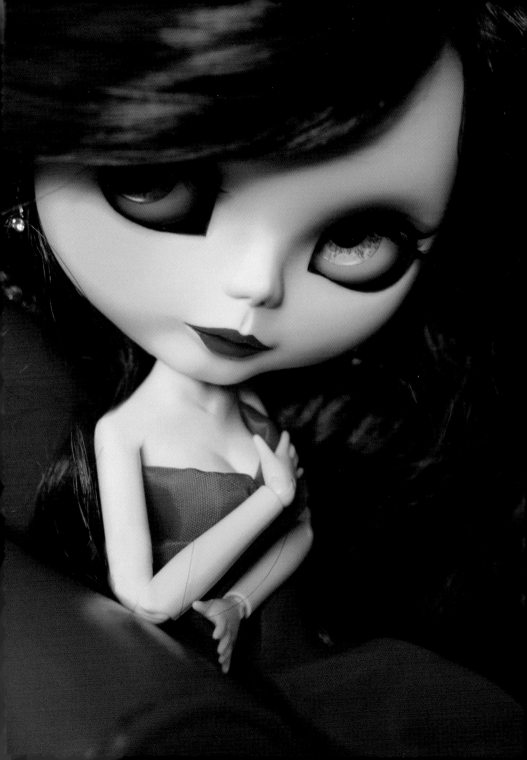

The King of Pop
a tribute to
Michael Jackson

181

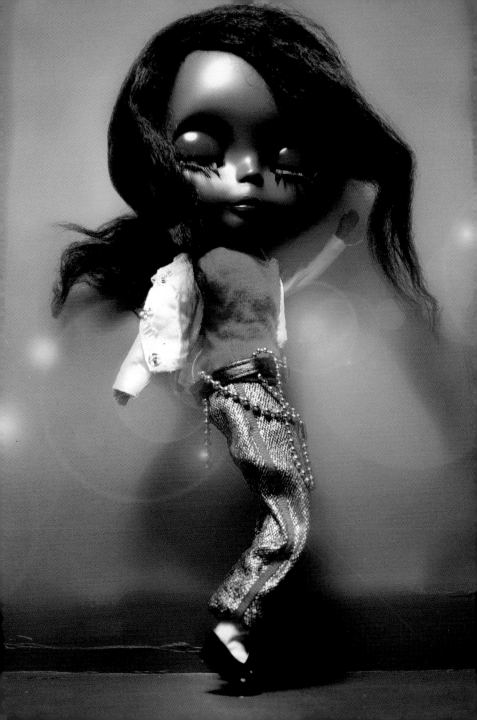

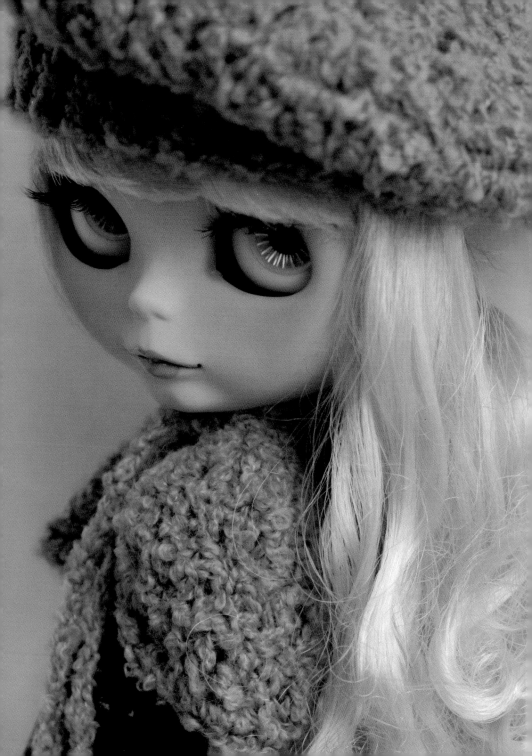

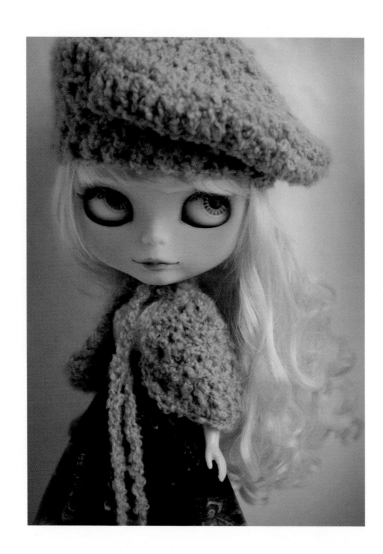

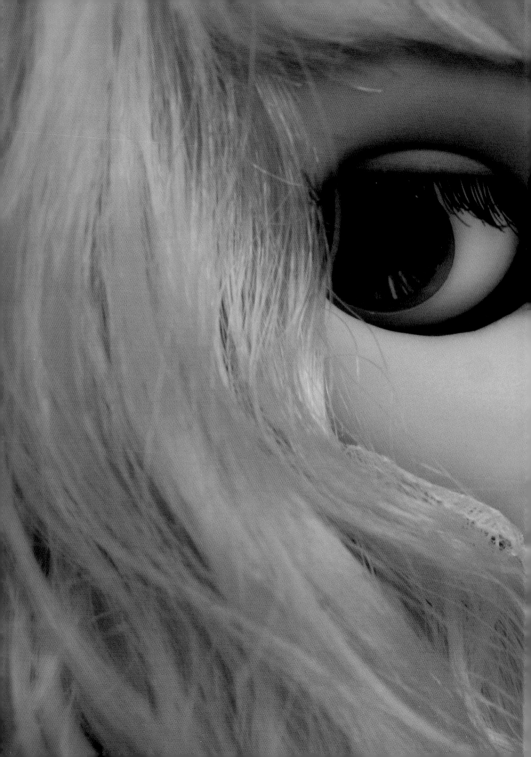

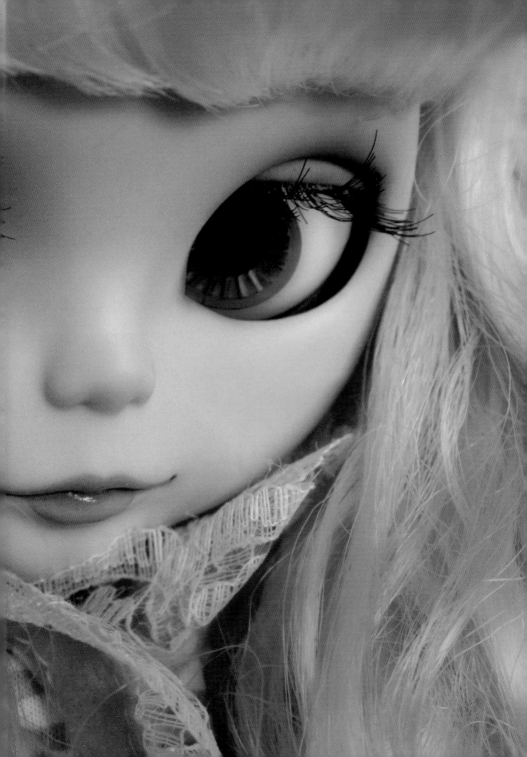

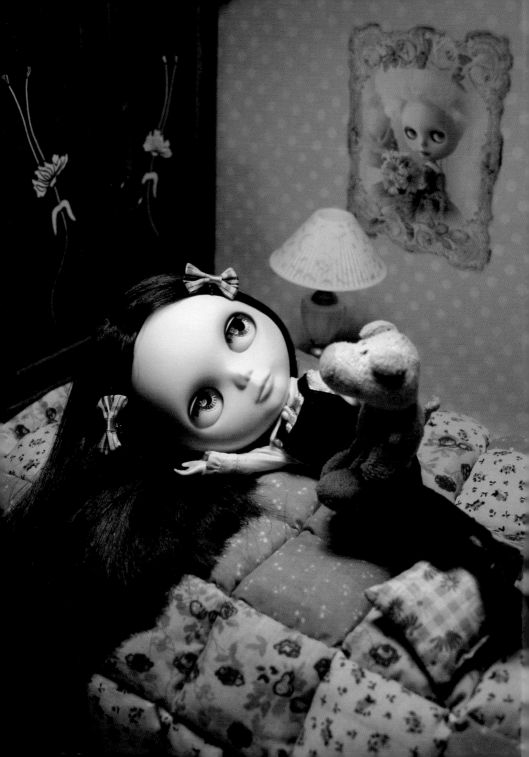

Changing

186

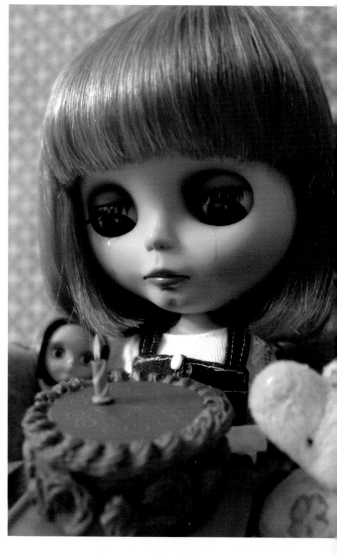

Getting
Older

187

Gwen
188 & 189

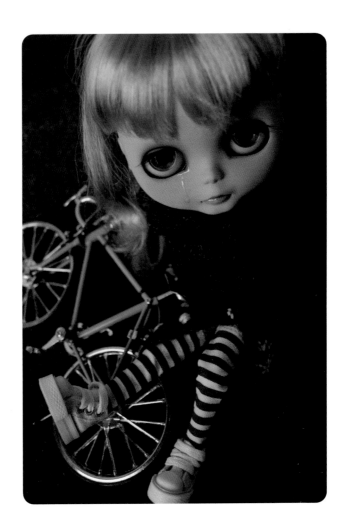

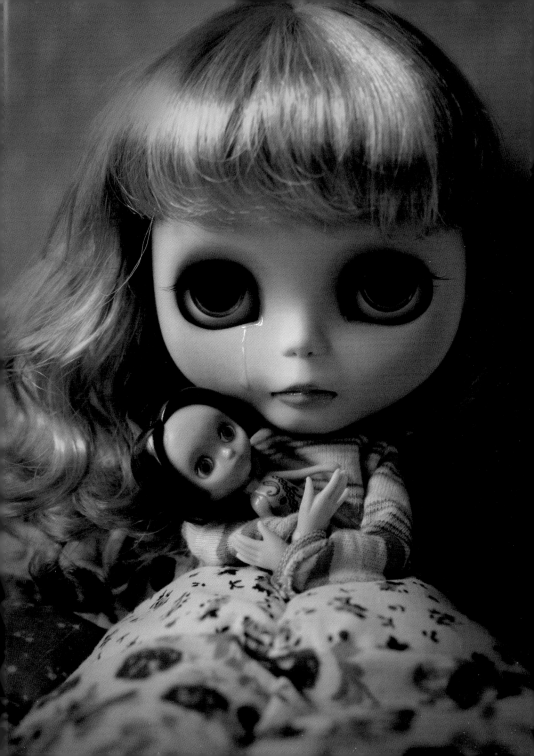

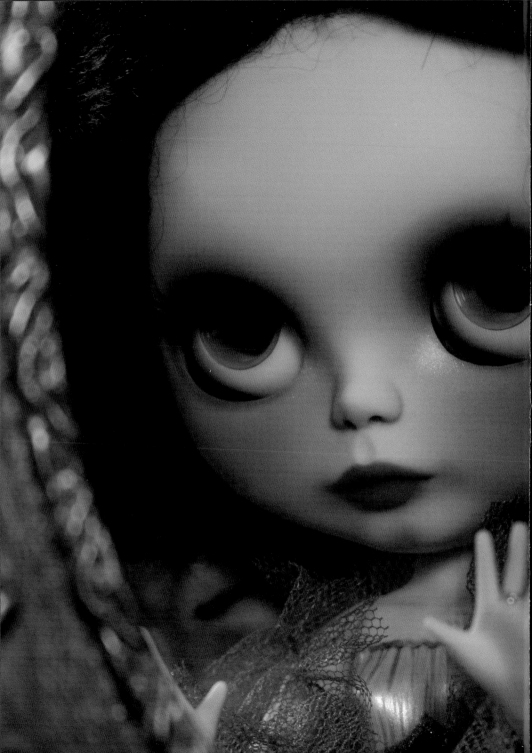

Exhibitions Exposiciones

2012
Blythe, A New Artistic Imaginary
Erregiro Custom Works & J. Alberto Rodríguez Illustrations
Curator, Clara Rodríguez Cordeiro
"O Gato Cósmico" GalleryShop
Santiago de Compostela, Spain

2011
Personal Projects Selection 2010-2011
Special Mention for the Personal Project "ALIEN DREAMS"
CoberturaPhoto Gallery
Seville. Spain

2008
"Me, Blythe. Plastic Lives"
Contemporary Art Museum Natural Gas FENOSA
Curator, Clara Rodríguez Cordeiro
A Coruña, Spain

2006
XIII Plastic Arts National Award
Fine Arts College of Seville Exhibition Hall
Monographic Exhibition "Moments"
Almazara Plaza Shopping Centre
Utrera, Seville. Spain

2005
XII Plastic Arts National Award
Fine Arts College of Seville Exhibition Hall
Seville. Spain

2004
Exposición Colectiva "Skin Contact/Barrier"
Exhibition Hall "El Postigo"
Seville. Spain
XXV Fine Arts College of Seville Anniversary
Seville. Spain
XXV National Contemporary Art Contest of the city of Utrera
Seville. Spain

2003
XXIV National Contemporary Art Contest of the city of Utrera
Seville. Spain
X Spring Exhibit
Casa de la Cultura de Utrera
Seville. Spain
"Three Visions of Art"
Municipal Theater Enrique de la Cuadra Exhibition Hall
Utrera, Seville. Spain

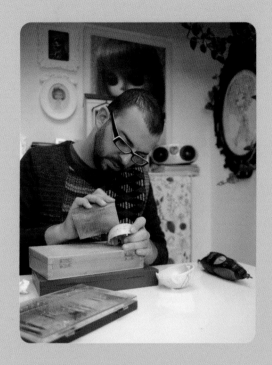

www.erregirodolls.com
www.flickr.com/photos/erregiro
erregiro@gmail.com